50 FINDS
FROM SOMERSET

Laura Burnett

AMBERLEY

To Rob, who supports my every step

First published 2023

Amberley Publishing
The Hill, Stroud
Gloucestershire, GL5 4EP

www.amberley-books.com

Copyright © Laura Burnett, 2023

The right of Laura Burnett to be identified as the
Author of this work has been asserted in accordance
with the Copyrights, Designs and Patents Act 1988.

ISBN 978 1 4456 6236 7 (print)
ISBN 978 1 4456 6237 4 (ebook)

British Library Cataloguing in Publication Data.
A catalogue record for this book is available from
the British Library.

Typeset in 10pt on 13pt Celeste.
Typesetting by SJmagic DESIGN SERVICES, India.
Printed in the UK.

Contents

Acknowledgements

The first thank you must go to all the people who have found the objects in this book and reported them to the Portable Antiquities Scheme (PAS) to ensure knowledge about them is not lost and can be shared with everyone.

While I was lucky enough to record many of the finds in this book many others have been recorded by colleagues, other Finds Liaison Officers, assistants, interns and many incredible volunteers, including self recorders. I would like to acknowledge the work of the original recorders of objects featured in this book: Kurt Adams, Ciorstaidh Hayward-Trevarthen, Naomi Payne, Edward Caswell, Alice Forward, Lucy Shipley, Susan Walker, Andrew Williams, Julie Shoemark, Vicky Lemmens, Maria Kneafsey, Phoebe Brice, Amy Downes, Sabrina Ruffino, Rob Webley, Wil Partridge, Nonn Bound, Anna Booth, Gareth Williams, Geoff West-Osborn, Sheila Hicks, Neil Wilkin, Richard Hobbs, Claire Goodey, Richard Henry, Alyson Tanner and Chris Lovell.

Finds Liaison Officers have to be a jack of all trades and for unusual finds rely on freely given help by specialists in certain periods or types of material. Thanks are due to the following experts: Dennis Parsons (Find 1), Michael Trevarthen (Find 3, and creating and demonstrating the reproduction scraper shown with Find 5), Richard Brunning (Find 7), Dot Boughton (Find 7b), Sally Worrell (Finds 8, 12, 17 and 18), Brendan O'Connor (Find 9), Andrew Brown (Find 13), John Pearce (Finds 15 and 17), Sam Moorhead (Finds 23 and 26), Helen Geake (Find 27), Barry Ager and Susan Youngs (Find 28), Jane Kershaw and James Graham-Campbell (Find 30), Mary Siraut (Finds 36 and 46), John Naylor (Find 37), Rob Webley (Finds 33 and 39), Graeme Lawson, Ian Riddler and Lorraine Higbee (Find 40), Edwin Wood (Find 39), Tom Mayberry (Find 41c), Jane Evans and Peter Maunder (Find 48).

In preparing this book various friends and colleagues were kind enough to read through and advise on certain sections: Ciorstaidh Hayward Trevarthen, Michael Trevarthen, Edward Caswell and Lucy Shipley. Amal Khreisheh and Bethan Murray helped advise on the finds in the Museum of Somerset and supplied photographs of some and Bob Croft supplied some views around Somerset. Rob Webley, Jonathan and Lizzy Burnett were kind enough to read the whole text and made it a lot more accurate and interesting.

All images, unless indicated in the text, are copyright of the Portable Antiquities Scheme and the hosts: for SOM, DOR, SOMDOR and DEV prefixed finds Somerset County Council or the South West Heritage Trust; for GLO prefixed finds Bristol City Council; for WILT prefixed finds The Salisbury Museum; and for SUR prefixed finds, Surrey County Council. The photographs of museum objects are all copyright of the South West Heritage Trust. Thanks are due to all providers for allowing these pictures to be reused in this book and to the other photographers of monuments and landscapes. Every attempt has been made to seek permissions for using copyright material, however if we have inadvertently used copyright material we apologise and will make the necessary corrections at the earliest opportunity.

Foreword

The places in which we live and work have a long past, but one that is not always obvious in the landscape around us. This is a forgotten past. Most of us know little about the people who once lived in our communities fifty years ago, let alone 500, or even 5,000 years past. Like us, they lived, played and worked here, in this place, but we know almost nothing of them.

History books tell us about royalty, great lords and important churchmen, but most others are forgotten by time. The only evidence for many of these people is the objects that they left behind; sometimes buried on purpose, but more often lost by chance. Occasionally, through archaeological fieldwork, we can place these objects in a context that allows us to better understand the past, but nowadays excavation is mostly development-led, so only takes place when a new building, road or service pipe, is being constructed.

A unique way of understanding the past is through the finds recorded through the Portable Antiquities Scheme, and those chosen here by Laura Burnett (Finds Liaison Officer for Somerset) are just fifty of over 30,000 from Somerset on its database (www.finds.org.uk). These finds are all discovered by the public, most by metal-detector users, searching in places archaeologists are unlikely to go or otherwise excavate. As such they provide important clues of underlying archaeology that, once recorded, help archaeologists understand our past – a past of the people, found by the people.

Some of these finds are truly magnificent, others less imposing. Yet, like pieces in a jigsaw puzzle they are often meaningless alone, but once placed together paint a picture. These finds therefore allow us to understand the story of people who once lived here, in Somerset.

Dr Michael Lewis
Head of Portable Antiquities & Treasure
British Museum

Introduction

As a finds specialist I am often asked 'What is your favourite find you have recorded?' It is always impossible to choose just one; I struggle with a top ten, so I am glad to be able to share a full fifty with you.

Small archaeological objects are all unique: even when a coin type was produced in the millions, they each have their own history of how they were used and of the people who used them. It is this interaction with people that makes them so interesting to me. Even an object that is beautiful in its own right, like Find 22 or 42, is made more interesting by considering the work and decisions of the craftsperson who made it, the wonder people of the time would have felt in seeing and handling it, and the story of its loss or deliberate burial.

When we see or handle an object, we are using physically similar eyes and hands to someone thousands of years ago, and we can share their physical experience. But by learning more about their society and its material culture we can try to understand how they interacted with and thought about the object, rather than our modern understanding and reactions.

All the finds have been discovered and recorded within the last fifteen years; they are new discoveries that are helping us understand more about Somerset's history. They have been shared through the work of the Portable Antiquities Scheme (PAS), which records archaeological finds made by the public. The scheme is explained more at the back of this book, including how you can contact its staff about anything you might have found. By recording finds they become part of everyone's shared knowledge and history.

Each find has its own PAS database number, for example SOM-C49769, and the full record can be seen on www.finds.org.uk/database. More information on sites mentioned in the book, and indeed a huge amount of information about sites in every parish in Somerset, can be found on the Historic Environment Record – links are in the Useful Sources section at the end. As the book focusses on finds recorded by the PAS some major finds found on excavations have not been included, such as the Beau Street Hoard of Roman coins found in Bath. Finds such as the Roman Shapwick Hoard of denarii and, in particular, the Frome Hoard of Roman radiate coins have also not been included as they have books written about them in their own right.

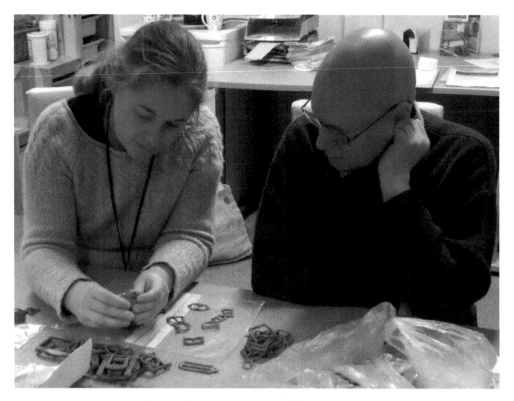

The author examining finds with their finder, John Ball. (Photo by Joseph Lewis)

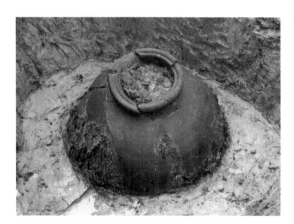

The Frome Hoard, found in 2010, is the largest Roman coin hoard in a single pot known from Britain. It held 52,503 coins dating to the later third century, mostly copper-alloy radiates with five silver denarii of Carausius, a breakaway emperor who ruled Britain and parts of Germany. The finder left it in situ allowing it to be carefully excavated, which meant we could learn much more about how and when it was buried. (Photo by Pauline Rook (SOM-5B9453)) 🏛

There is always more to learn about finds, as new techniques for analysis are developed and that is only possible when finds are available for more study, usually in a museum. Not all will be on display; museum reserve collections are used for study and in temporary exhibitions, in the museum or out in the community. Finds held by museums are shown with a 🏛 symbol. Most are in the Museum of Somerset in Taunton; finds in other museums are specified.

The finds in this book are ordered chronologically with a short introduction given to each period. This map allows you to look up finds from a particular area.

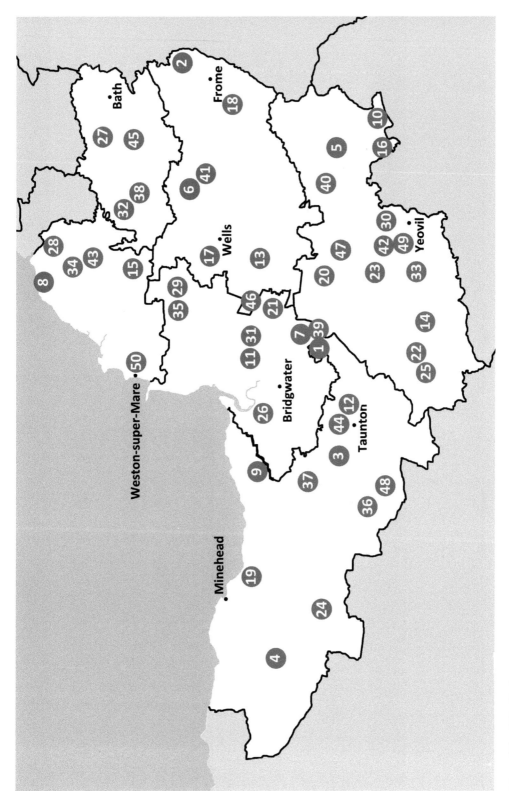

Map of the fifty finds.

Somerset's Landscape

All counties in Britain are diverse in their landscape but Somerset, an unusually long county with no single, central, city to provide a religious, political, and economic centre, can feel more diffuse than most. It is a long way, physically and economically, from Frome on the edge of south-east England to Chard in the depths of agricultural South Somerset to

Catherine Hill in Frome, showing the golden limestone, different types of which are found across eastern Somerset from Ham Hill to Bath. (Photo by Nigel Jarvis/Shutterstock.com)

Dulverton, remote on Exmoor, to the port town of Portishead, almost within the suburbs of Bristol. All, however, are small towns and modern Somerset is united perhaps in its rurality, with no large cities and often difficult transport links.

This fragmentation is in part a product of its underlying geology, which divides and defines parts of the county. The central wetlands of the Levels and lowland Moors, the second largest wetland area in Britain, are crosscut by hill ranges including the Poldens and Mendips. The Bristol Channel, wetlands and larger rivers of the Tone, Parrett, Brue and Avon now feel like barriers in the landscape. In the past, before good roads were built, they would have been routeways as water transport was cheaper and easier. Around the edge of Somerset are further areas of high land, where the physical differences shape the human use of the land as much today as they did thousands of years ago. Exmoor and the Brendon Hills, the Blackdowns, Selwood Forest, the Quantocks, and the limestone ridges of the Somerset coalfields and south of Bath provide very different resources than the rich agricultural areas of South Somerset and the vales such as Taunton Deane or the Gordano and Chew valleys.

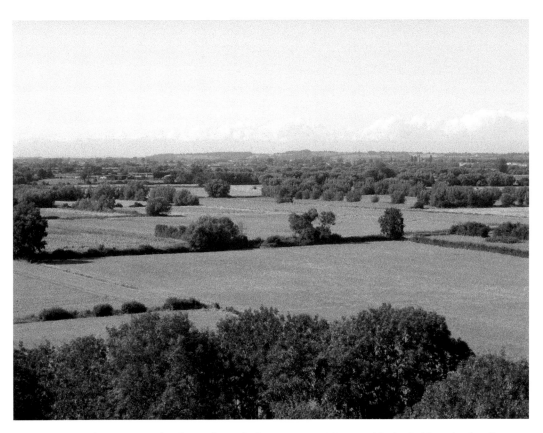

View north-west over the drained Levels from Barrow Mump with the Poldens in the distance. (Photo by Blair Webley)

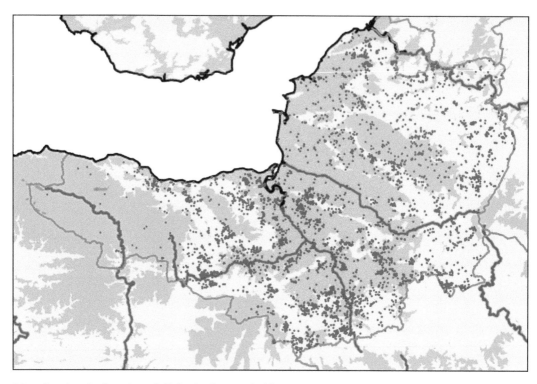

Map showing the location of all the finds recorded by PAS in Somerset as red dots, against areas of high and low ground and the main rivers.

This map shows all the finds recorded by the PAS against the landscape. It is clear that it is not the dark orange highlands or the green lowlands that were most attractive to human settlement in the past but the boundaries – the places these different landscapes and areas meet. The edges of the ranges of hills, and the islands, even the very small ones, hidden under red clusters of finds, were the best place for settlement, and the finds left behind reflect that.

Palaeolithic to Neolithic (850,000–2100 BC)

The first evidence of humans in Britain dates to around 850,000 years ago. At this time Britain was joined to Europe by a land bridge. Since then, humans have repeatedly moved into Britain during warmer periods, retreating again during ice ages when much of the country, sometimes including Somerset, was covered in ice. For some periods the landscape

Several caves in Cheddar Gorge in the Mendips have been excavated and contained remains of later Ice Age animals and human tools, burials and even some art pieces. (Photo by Lukasz Malusecki/Shutterstock.com)

would be tundra-like, and people would have mostly hunted herds of large mammals. In the warmest periods the climate would be similar to or warmer than today. Reflecting this variation, bones from a wide range of animals who need different climates, from hyena to mammoth, are found at Banwell Bone Cave.

Because of these huge changes in landscape very few of the objects left behind, stone and bone tools and later art pieces, survive in situ (i.e. where they were lost or used). Most objects are found as chance finds that have been moved by rivers or glaciers. Other objects, in bone, skins and plant material – like baskets – are lost entirely. Only in a few protected environments do sites remain in anything like completeness: in caves, fissures and under rockfalls or gravel build up. Luckily Somerset has many caves, mainly in the limestone Mendips. One of the earliest sites in the whole country is in a quarry near Westbury where stone tools and bones with cut marks have been found in deposits that are about half a million years old. The humans at the time were probably the ancient human species *Homo heidelbergensis*, and evidence of Neanderthal and other sub-species of humans have also been found in Somerset, including their bout-coupé handaxes.

Rapid warming at the end of the last glacial period, around 10,500 BC, created a climate very like today with a few slightly warmer or cooler periods, such as the 'Little Ice Ages' of the sixteenth and nineteenth centuries AD in Europe when even large rivers would regularly freeze in the winter. The early part of this period, 8000 to 4500 BC, is known as the Mesolithic. For probably the first time *Homo sapiens*, humans of the same species as today, moved into Britain. The expanding plant and animal life supported a hunter-gatherer

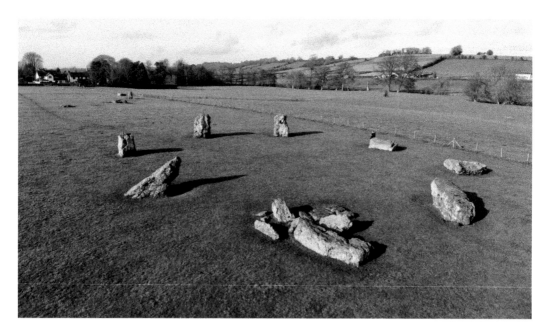

One of the three Neolithic stone circles in the Stanton Drew complex. (Photo by Gary Alford/ Shutterstock.com)

14

lifestyle where people would move within the landscape seasonally to exploit different areas. The wetlands of the lowland Moors and Levels would have provided a rich environment with many edible and useful plants, fish and birds. Some of the earliest burials and cemeteries in the country are found in Somerset: at Gough's Cave in Cheddar Gorge, Aveline's Hole, and in the open air at Greylake, on a sandy island overlooking the Levels. Again, almost all the tools and crafts from this period have been lost, with often only a few flint tools remaining to identify a site.

Around 4500 BC agriculture was first introduced to Britain. Hunter-gatherers managed their environment to encourage plants and animals they needed but the new agriculture meant completely new crops and domesticated animals were imported as a main source for food and animal products. To manage these crops and animals people became more settled. People also began to mark the landscape more, with stone and earthworks, with concentrations of monuments around Priddy and Stanton Drew. While the main remains are still flint tools, gold started to be used and pottery became more useful as people moved around less. In Somerset we have amazing remains of wooden trackways, such as the Sweet Track of *c.* 3800 BC. These show the woodworking skill achieved with flint tools and demonstrate that the wild resources of the Levels and islands continued to be important alongside agriculture. Finds preserved in the peat show some of the diversity of animal skin and plant-based objects people used at this time, including a wonderful wooden toy axe that probably belonged to a child.

Toy axe found next to the Sweet Track; it is the same shape as a real axe, like Find 4, and shows how that axe would have looked hafted. (Photo courtesy of the South West Heritage Trust)

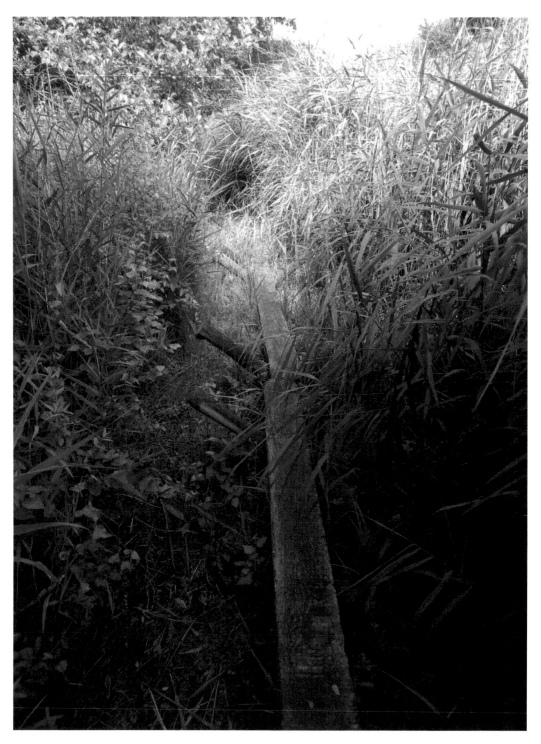

Reconstruction of the Sweet Track at the Avalon Marshes Centre; the original is buried in the peat below and dates to 3807 BC. The track ran across marshy ground and water, linking the island of Meare to the Polden Hills. (Photo by Blair Webley)

Handaxes, with choppers and some flakes, are the main stone tools we find from the first 750,000 years of human history in Britain. Similar handaxes to this have been found on butchery sites but may have had multiple uses.

This chert handaxe is of 'ficron' type, with an elongated, narrow and thinned point and larger rounded butt. The axe was formed by removing flakes from both sides of a large core of stone. The butt was worked and shaped but some of the stone's original surface, the cortex, was left. In the hundreds of thousands of years it was buried, the surface has developed a thick, tactile quality as the cortex has reformed and turned orange from iron staining. Some areas of damage are a similar colour and may have happened during use or soon after, including the large piece missing from the lower part of one face, which has left it concave. More modern damage, including at the missing point, goes through this surface to the mid-grey/brown chert of the tool. It is probably Greensand derived chert from the Blackdown Hills.

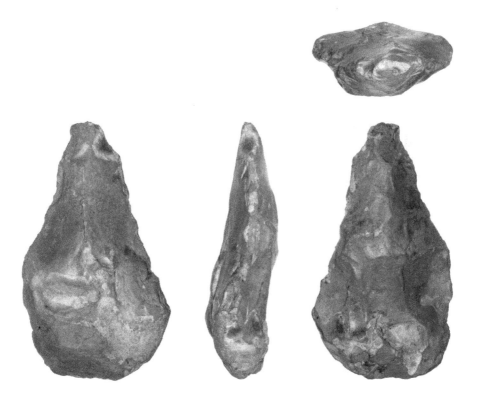

The narrowed blade was ideal for cutting and the rounded butt gave it weight and was a good place to hold the axe.

2. Flint blade core (SOM-9021CC)
Mesolithic (10,000–4500 BC)
Found in Beckington in 2014. Length 38 mm.

This core was found with a group of other material, including some Mesolithic microliths and later, Neolithic, material, suggesting a site with repeated periods of use, all mixed by ploughing. The core has been very carefully shaped, with pieces removed in a deliberate, predetermined sequence. This resulted in a flat platform from the top from which dozens of similar sized, even blades could be removed, running down the sides. Unlike the

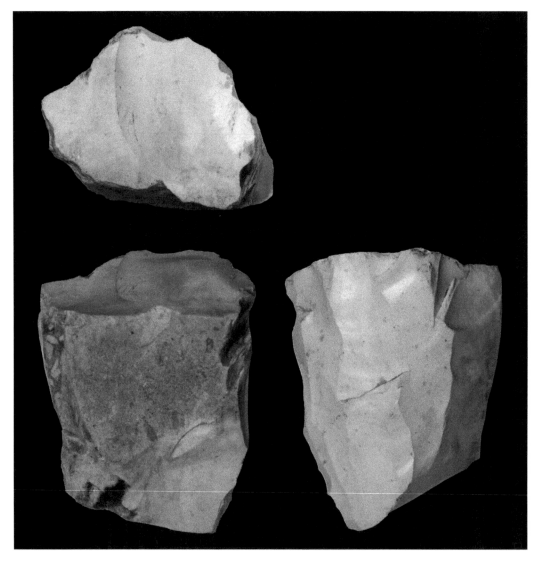

The platform of the core is at the top and scars from parallel blade removals can be seen on the right.

Group of blades and waste pieces (debitage) found on the same site.

handaxe where what was left in the centre was the useful part, here the removals are what was taken away to be used and the central 'core' discarded.

Because Mesolithic sites were often temporary, they leave few of the pits, ditches and walls we might think of on a traditional archaeological site. They are therefore hard to locate through aerial photography or other large survey techniques. Often it is only the archaeologist, or, more often, member of the public, finding a scatter of flint tools in a field and recording them, that identifies a potential site (SOM-670FF7).

This tiny, pale brown Greensand chert microlith was formed from a small part of a blade struck from a core. The edges have short retouch: delicate resharpening done after the main shape was made. It is rare to find a microlith made of chert as the fine working required is difficult on this granular material.

Microliths would be embedded in wood or antler, sometimes many together to make a sickle to cut plants or as barbs on an arrow or harpoon. The small microliths and blades made very efficient use of material. The mobile Mesolithic people were already travelling across the landscape so were usually able to acquire enough very high-quality flint from the chalk downlands in eastern Somerset for these small microliths, only using chert for larger tools.

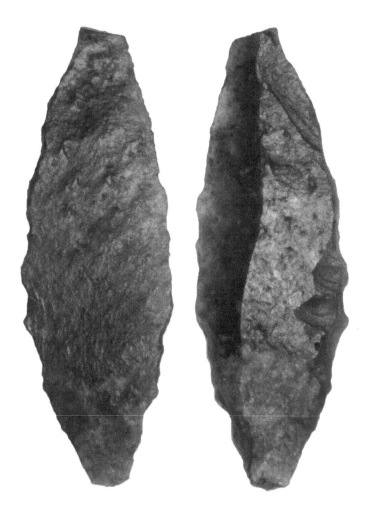

4. Polished flint axehead (SOM-CE09D9)
Neolithic (2750–2350 BC)
Found in Cutcombe in 2016. Length 132 mm.

This flint axehead would originally have had a wooden handle and probably been used for woodworking. It has been worked on both faces; first the shape was formed by removing flakes, then the cutting edge was ground and polished to remove the majority of flaking scars. The technique of polishing out flake scars, using a polishing stone or sand and leather, is very labour intensive.

Polishing the blade edge can make the object less likely to break so it lasts longer but it is also an aesthetic choice and suggests time to do extra finishing to make a luxury object. Flint is not found in the area, apart from small pieces in rivers and on beaches, so the material for the axe has been brought probably 50 miles, from eastern Somerset. This axehead may have been a display piece but it was also a functional one, with polishing restricted to the most useful area and an asymmetrical cutting edge, suggesting it was used and re-sharpened.

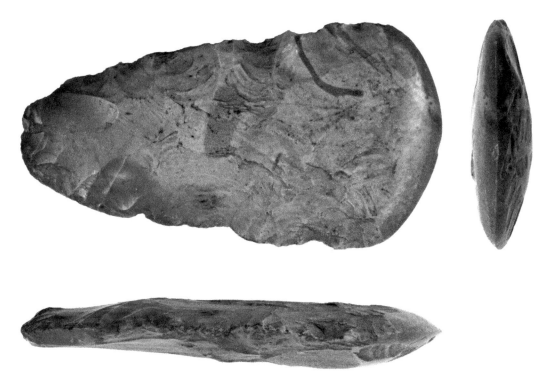

View of the entire axehead.

Detail of the blade in profile showing the polished end and more uneven flaked areas.

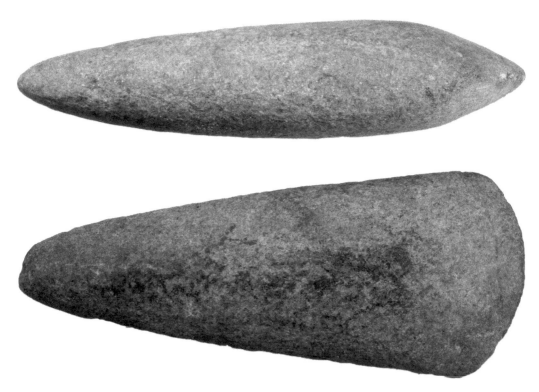

As well as flint and chert, axeheads were also made in hard stone, such as a Cornish greenstone example found in Rode in 2018. 170 mm long (WILT-BD2979).

5. Flint end scraper (SOM-7E08E4)
Neolithic (4000–2100 BC)
Found near Wincanton in 2012. Length 61 mm.

Scrapers are relatively common flint finds in all periods from the Upper Palaeolithic to the Bronze Age. This scraper was made on a blade and the curved end was retouched with smaller removals to create a 45-degree angle. Scrapers were used to scrape animal skins and strip plant material and wood. They were essential to process food and material for clothes, baskets, rope, and hundreds of uses besides. They were quick and easy to make, even for people with limited experience, although better ones, like this, were made on skilfully prepared blades.

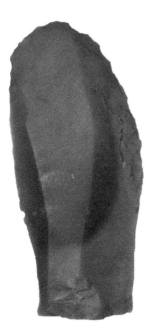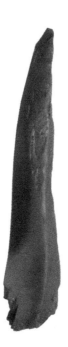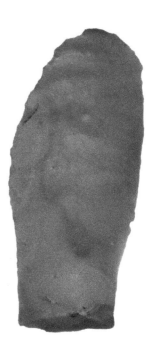

End scraper.

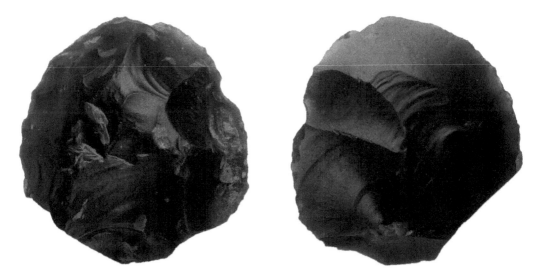

This scraper is the same shape as a thumbnail and would be held between the thumb and bent forefinger. It is made of high-quality black flint; the ripples from stone hammer impacts are clearly visible. Found in Mudford in 2019, 26 mm in length (DEV-5DF01D).

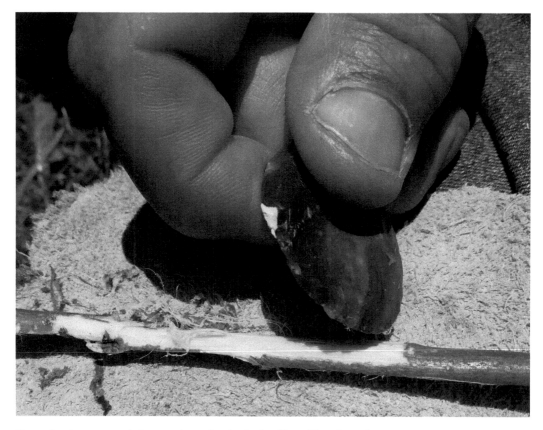

Reproduction scraper being used to take the bark off a willow branch.

Bronze Age and Iron Age (2300 BC–AD 43)

As the name suggests, in this period we see the first use of metal for tools and weapons, firstly small amounts of copper, then bronze (a mix of copper and tin). Both metals would have needed to be traded long distances and metal working requires specialist equipment and skills. This kind of specialist production, for goods that only need to be acquired occasionally, encourages long-distance trade and economic connections. Many bronze items survive, in part because people of the time deliberately deposited items in undisturbed locations. In contrast, iron is relatively rare even after its introduction in 800 BC. It rusts quickly in active soils and so seldom survives beyond a few centuries. Both bronze and iron could also be recycled into new objects.

In the Bronze Age we also see more settled communities, although people might still move seasonally to exploit grazing and other resources, particularly on Somerset's uplands and wetlands. While agriculture starts in the Neolithic it intensifies through the Bronze Age with more evidence of landscape division, fields and rising population, particularly from around 1400 BC when there seems to be a change from the Beaker period of settlement and material culture, which runs across the Late Neolithic to Early Bronze Age. Thin upland soils, exploited for 2,000 years, were eroded, and as the climate became wetter a new agriculture developed. More substantial houses, mostly roundhouses, start to be used from 1700 BC and there is more variety of separate buildings for animals, work and storage.

It also seems likely the population starts to be more stratified. In the Middle Bronze Age, we see more use of bronze jewellery and ornaments. At the end of the Neolithic into Early Bronze Age some individuals start to receive special burials in individual barrows, which become a focal point for other simpler burials and interred cremations. These barrows remain on the high points of the landscape today, visibly dominating the landscape and providing a fixed point for people below.

Iron Age society was agricultural with people living in small villages of round houses. Hillforts, like Norton Fitzwarren, Ham Hill and Portbury, provided central gathering places for larger communities, with only some having evidence for small

numbers of permanent residents. In Somerset some of the most famous remains of this period are the lake villages at Glastonbury and Meare, which show the continued exploitation of the Levels and also developing long-distance trade in specialist craft, in glass working and pottery.

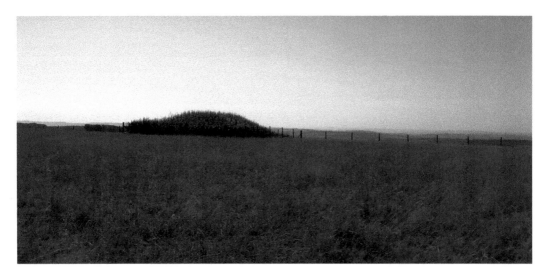

One of the Bronze Age Lype Hill barrows on Exmoor. They were later used as markers on the Saxon Herepath and by the modern Ordnance Survey.

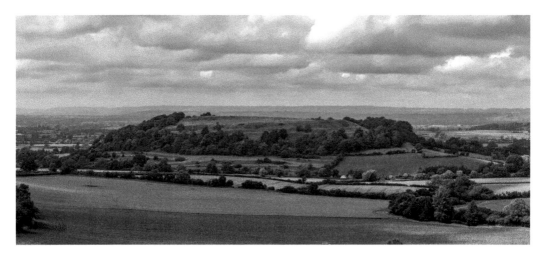

Cadbury Castle hillfort. The earliest known use of this site is Neolithic, and there is an important Bronze and Iron Age settlement, but the main defences were built in the first century BC. There is evidence of a probable Roman temple and the site was reoccupied in the fifth and sixth centuries including the building of a great hall. This later reuse has led some to link the site to the mythical Camelot of King Arthur, also suggested by its local name of Camalet. (Photo by Rb3legs/Shutterstock.com)

6. Flint barbed and tanged arrowhead (SOM-51F507)
Late Neolithic to Middle Bronze Age (2500–1150 BC)
Found in Chewton Mendip in 2011. Length 18 mm.

While large display pieces, such as axes, started to be made in copper and then bronze, smaller tools, including scrapers, were often still made in flint throughout the Bronze Age and into the Iron Age. Bronze arrowheads are rare; some may have been recycled but arrows were frequently lost with prey so expensive bronze was risky to use.

Right at the end of the Neolithic we see the introduction of carefully made barbed and tanged arrowheads, which continue in use through the Bronze Age. The central tang was hafted into a wooden arrow and the barbs would hold it in the animal. These arrowheads take skill to make, to create the thin blade then shape it, but are relatively quick to produce.

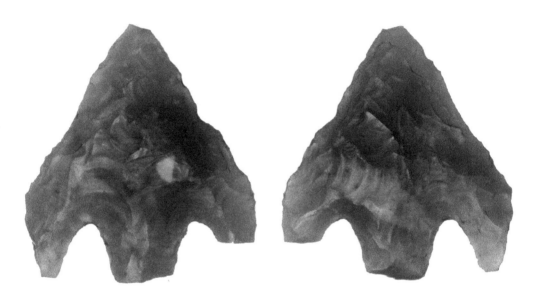

7. Copper-alloy dagger (SOM-AC79FD)
Early Bronze Age (2,150–1,600 BC)
Found in Middlezoy in 2018. Length 111 mm.

Many Bronze Age objects we find today appear to have been deliberately deposited, often in wet environments, possibly as an offering. Material from Middlezoy, found on the edge of the sand island near an old channel of the River Sowey, were probably deposited into water. As well as this dagger, an axehead of 1400 to 1150 BC and another of 950 to 750 BC (pictured) were found around the island edges, showing this practice, and the significance of the site, was very long lived.

The dagger hilt is damaged, but one rivet remains and would have held a wooden handle. On both faces are skeuomorphs, formed where copper corrosion has leached into and taken the form of organic material, probably the wooden hilt and grass or bracken held against the blade during deposition.

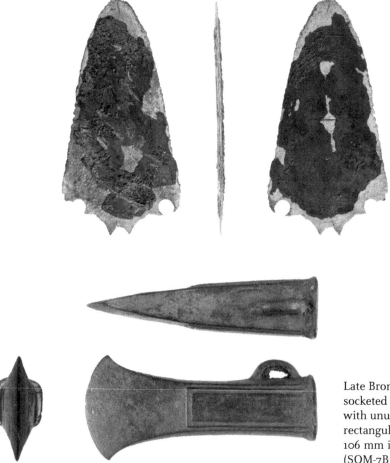

Late Bronze Age socketed axehead with unusual raised rectangular decoration, 106 mm in length (SOM-7B35AD).

8. Copper-alloy dress pin (GLO-439E61)
Middle Bronze Age (1400–1250 BC)
Found in Portbury in 2012. Length 170 mm.

This large decorative pin would probably be worn through a cloak or mantle, holding the sides together at the front or shoulder and with the decorated upper part very visible. The loop would allow it to be attached to clothing for safety or have an additional decoration hang from it. The bend is probably damage but could have been part of use to make it more secure. It is a 'Picardy' type; as the name suggests, such pins are found across Europe as well as in Britain but are quite rare.

This period of the late Middle Bronze Age is sometimes called the 'Ornament horizon' as bronze starts to be used to make more jewellery and ornamental pieces, as well as axeheads and spearheads.

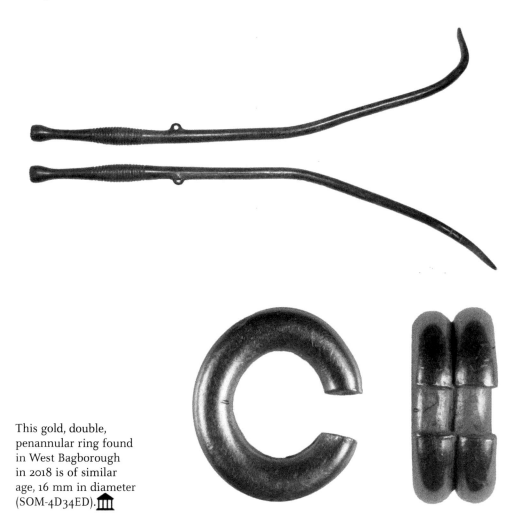

This gold, double, penannular ring found in West Bagborough in 2018 is of similar age, 16 mm in diameter (SOM-4D34ED).

9. Copper-alloy axehead (SOM-63A847)
Middle Bronze Age (1400–1150 BC)
Found in Holford in 2012. Length 105 mm.

This long, narrow axehead is of the Taunton-Hademarschen type, several of which have been found in the county. Previously they were thought to be Late Bronze Age, but an example found in a hoard in 2003 confirmed they date to what is known as the 'Taunton' period of the Bronze Age after a hoard found on the Taunton Workhouse site.

The field where it is found is now dry agricultural land, but the orange iron pan concreted across the mouth opening shows the axe was previously in standing water for a long time. When this was brought in for recording I hoped the iron pan might have preserved some of the organic handle so arranged to have it X-rayed. The X-ray shows the remains of a wooden handle preserved inside the axe, which would have been formed from a naturally bent or branching piece of wood.

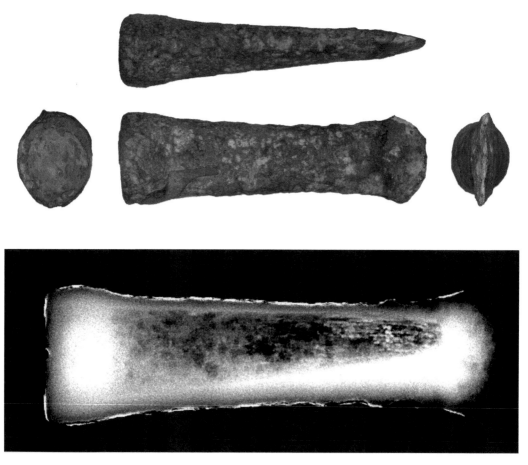

X-ray of the axe – the darker area in the centre is the remains of the handle.

10. Copper-alloy sword (DOR-813231) 🏛
Middle Bronze Age (1400–1300 BC)
Found in Henstridge in 2017. Length 185 mm (folded).

As well as often being deposited in water, bronze items were sometimes deliberately broken, bent or 'killed' before deposition. This effort to make them unusable emphasised they were being deposited as an offering, rather than stored for recycling. This sword was bent in two places before being buried with an axe. Bending it this way would have required heating and great skill to create such folds in a long sword without breaking it. The bent tip of this spear may also be deliberate.

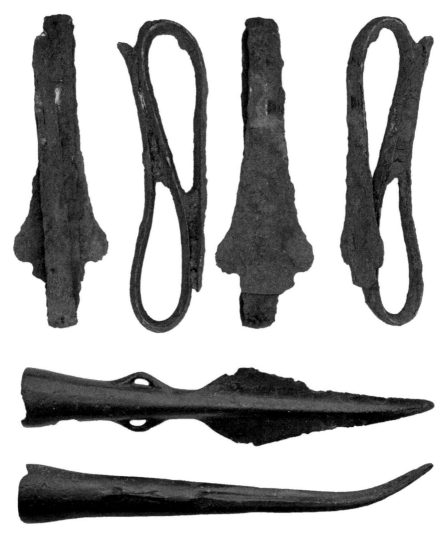

Middle Bronze Age spearhead found in Saltford in 2020, 107 mm in length (GLO-3AB9E7).

11. Pottery jar or bowl sherd (SOM-5E3915)
Iron Age (300–1 BC)
Found in Woolavington in 2013. Length 51 mm.

The piece is from a rim of a rounded bowl or deeper, globular jar and has a curved out upper edge. Both surfaces are smoothed, and the external surface is decorated with curved lines creating a swag like pattern. The space between and under the curves is shaded with oblique lines.

This type of pottery was called 'Glastonbury ware' after pieces found in the Iron Age lake village. The kilns have not been found but differences in the clays used to make them suggest such pots were made in several places across the South West by skilled potters who sold their wares over long distances. Because of this wider production and use it is now called 'South West Decorated ware'.

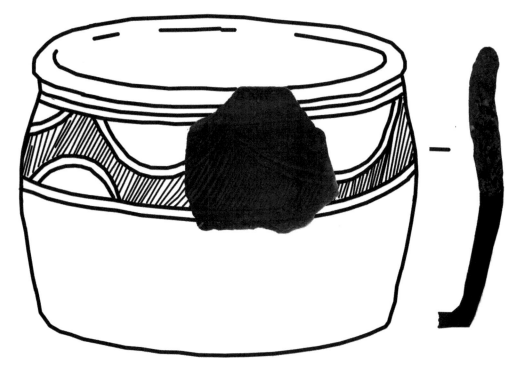

Pottery sherd shown against a possible reconstruction of the entire pot; based on more complete examples from Glastonbury and Meare Lake villages.

12. Copper-alloy sword pommel (SOM-o88DFF)
Iron Age (150–1 BC)
Found in Ruishton in 2015. 33 mm tall.

The slit in the base of this human head shaped pommel would have sat over the end of the sword's handle, flanked by projections shaped like arms. Below the chin the neck ends in an old break across a rivet hole.

Because few clothes or pictures survive from this period in Britain, objects like this are really important in understanding what people wore and how they dressed their hair, both usually important status and cultural markers. Above the face is a decorated band running along the hairline, which may indicate a decorative head band or plaited or bound hair. Behind the band the hair is in combed lines running straight back to a plain band at the back with a central knot, perhaps a small bun, hair net, or further decorative band.

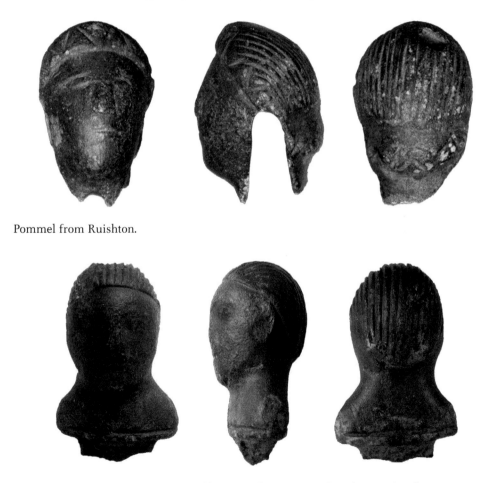

Pommel from Ruishton.

A second sword pommel with a small part of the iron grip found in Fitzhead in 2019, 36 mm high (DEV-5965A6).

In the Iron Age coins start to be used for the first time in Britain. We can map areas dominated mostly by coins of one type or group and this might suggest some sort of political or economic coordination across a wide area. We know from Roman texts that the Durotrigians were politically dominant in Dorset at the time of the Roman conquest, and coin finds suggest they also dominated some of Wiltshire and Somerset. Continuity in coin design might suggest they may have been established as a confederacy or tribe for at least a century. Coins also suggest the group originally extended further into Hampshire and the Isle of Wight before being pushed out, or the group splitting.

Durotrigian coins are unusually conservative; the design doesn't change from when they were first produced in around 80 BC until the Roman conquest. The metal, however, does change, from gold to silver to a copper-silver mix (billon) to plain copper. The shift from gold seems partly to reflect a reduction in gold payments coming into the country after the Roman conquests of Gaul. It may also reflect a movement from coins being special items used in gift giving or military and political payments to something used more regularly in everyday purchases.

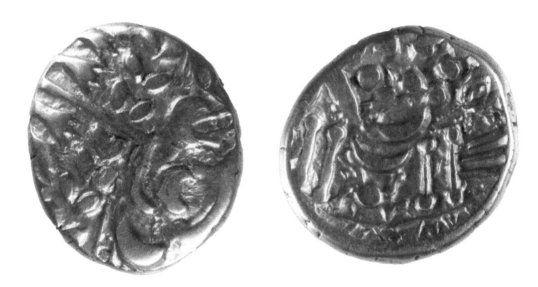

Gold stater with stylised wreathed head of Apollo on one side and disjointed horse on the other.

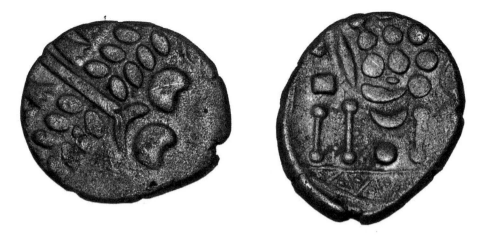

Silver stater found in Backwell in 2010, 19 mm in diameter (GLO-3EC292).

Copper-alloy stater found in Drayton in 2019, 18 mm in diameter (SOM-653F5D).

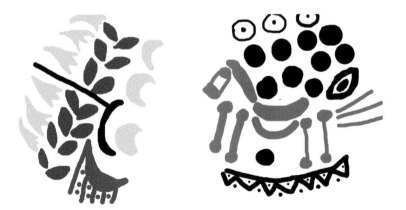

Iron Age coins were made smaller than the die so usually part of the design is off the edge. Here is a sketch of the full design: the hair is in yellow, the mantle in blue, the wreath in green, and the horse, on the reverse, in red. There are no facial features remaining.

14. Copper-alloy handle escutcheon (SOM-41CB43)
Late Iron Age (50 BC to AD 40)
Found in Dinnington in 2011. Length 32 mm.

This piece would have been attached to the rim of a copper-alloy sheet bowl by the Y-shaped rivet on the back. It would have held a ring-shaped handle, which could be used to suspend the bowl on a chain or rope. The decorative front would have concealed the attachment with the handle hanging down below it. Finds of several similar pieces have been recorded by PAS in the last ten years. These, along with a few older excavated examples, suggest this form of handle, with a Y-shaped back, is only found in Somerset and surrounding counties. Such a local distribution implies these types of handles, and therefore the bowls too, were locally made.

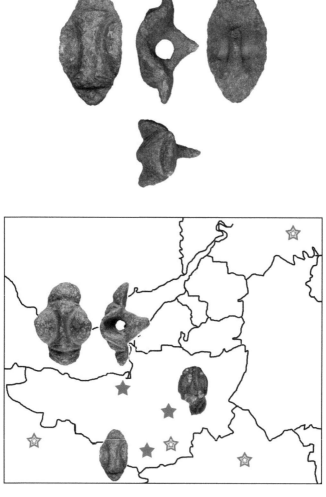

Map of known examples including photos of the three on PAS (filled in stars; open stars are previously known examples).

Roman (AD 43–410)

For many people life may not have changed much with the Roman conquest. The farming way of life continued, with iron-shoed ploughs now allowing exploitation of heavy soils in the valleys and clay areas. By the Late Iron Age people were already part of larger political groups, using coinage, wearing clothes fastened with brooches, mass-producing pottery and iron, and trading goods over long distances with central marketplaces such as the 'oppidum' near Ilchester. Some of this social change may have come about in reaction to the Roman expansion as groups in France and southern Britain consolidated to fight both the Romans and each other, and to secure access to luxury Roman imports.

There is a gradual change through the Roman period, however. By the second century coinage started to be used frequently even on very small, rural sites. This suggests everyone was using money more, to make regular purchases of imported or manufactured goods, or pay taxes. With the improving climate there was more exploitation of the Levels, for grazing and salt production. Roads were established, and towns – centres of administration and trade. Somerset had many small towns, as at Gatcombe, North Somerset, but also the important town of Bath, with its major Roman-style temple to a blended Roman and traditional goddess: Sulis Minerva.

South Somerset and the drier areas of North and North East Somerset become more densely settled with multiple farm sites, and larger farms or villas every few miles. The coinage and other luxury goods recorded through PAS emphasise the wealth and importance of South Somerset towards the end of the Roman period when it was probably a major exporter of grain.

Over the last ten years we have discovered more typical Roman material culture in the western part of the county, with new sites discovered up the Vale of Taunton Deane, along the coast, and on Exmoor. The finds recorded through the PAS are an important part of changing our understanding. This area may have seen a blending of ways of life; there is a continued use of roundhouses rather than square buildings adopted elsewhere. The volume of material recorded through the PAS means we can also start to analyse regional patterns in coin and artefact use and recognise what is distinctive to Somerset.

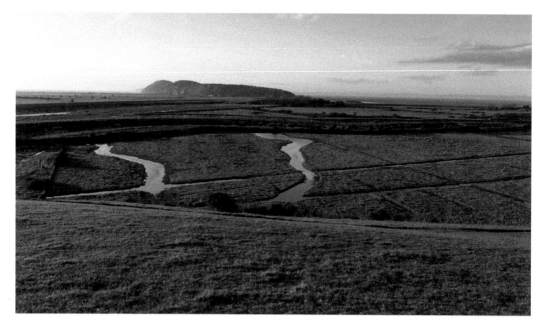

The prominent coastal headland of Brean Down is topped by a Romano-British temple. It would have overlooked an extensively exploited landscape, including drained areas for grass and arable crops and salt production on the tidal marshes. (Photo by C. Parr/Shutterstock.com)

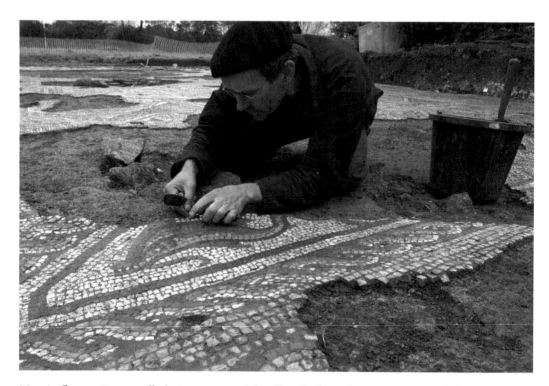

Mosaic floor at Lopen villa being excavated by Alan Graham. (Image courtesy of the South West Heritage Trust)

15. Copper-alloy *capricornus* **figurine (SWYOR-29B362)** 🏛
Roman (AD 43–410)
Found in Burrington in 2012. Length 250 mm.

Capricorn was a mythical animal with a goat's foreparts and fish's tail. This figure is finely moulded with details such as the hair and scales picked out with incised lines. It appears to be complete apart from the missing horns, with no sign of attachments to a larger item.

The *capricornus* is associated with the first emperor, Augustus (31 BC–AD 14), and military units founded by him, such as the Legio II Augusta. They were based in Caerleon, just over the Bristol Channel, and involved with lead mining on the Mendips. Augustus was probably conceived under the sign of Capricorn and adopted it as his personal sign due its association with rebirth after the dark days of the Roman civil wars. The Capricorn was also titled as a ruler of the West. Its dual nature was thought to give it dominion over land and sea.

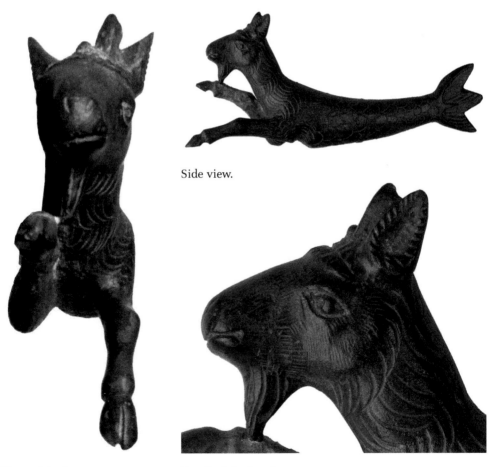

Side view.

View of the front. Detail of the head.

16. Copper-alloy 'strip bow' brooch (SOMDOR-374E54)
Late Iron Age to Roman (AD 25–50)
Found in Milborne Port in 2006. Length 60 mm.

After pottery vessels and coins, brooches are the third most common object type recorded from the Roman period. They would be worn by men and women, often in pairs, one at each shoulder. In the Late Iron Age and Early Roman period we see many distinctive dress accessories produced and worn in Somerset and the surrounding areas. Moulds have been found at Compton Dando where some brooches were made. This suggests a continuing regional style, and possibly identity, at the same time as other more international fashions were being adopted. The early adoption of bow brooches, compared to northern Britain, also tells us about the way clothing was worn, even though the cloth seldom survives.

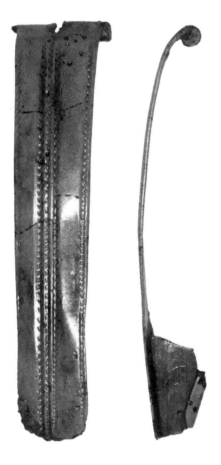

Strip bow brooch, popular before and after the conquest, mainly in the Durotrigian area. Maiden Castle type.

The local T-shaped brooch style with hinged top bar was very adaptable and in some cases the appearance of a newly fashionable type, like the trumpet-headed brooch, is created on the front of a brooch that, in terms of fastening and manufacture, continues the local style and techniques.

Cells containing enamel became fashionable in the later first century. The head loop, to link a pair of brooches with a chain, is also a later development.

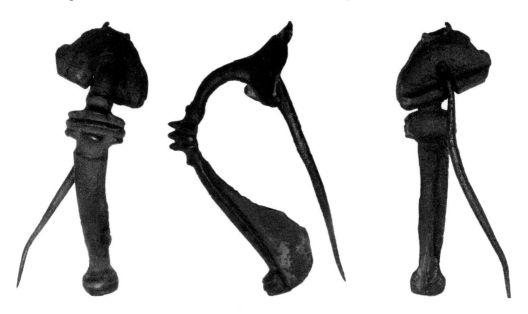

Above: Trumpet head and trumpet-style waist moulding on a T-shaped brooch. Found in Mere in 2012, 51 mm long (SOM-8D8837).

Right: Developed T-shape brooch of AD 75–150. Found in Timsbury in 2017, 42 mm long (GLO-5F2644).

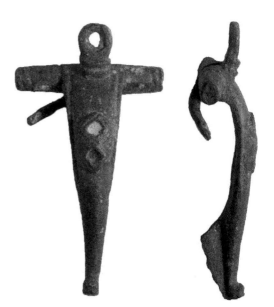

Find 17. Lead pig ingot (SOM-23F798) 🏛
Roman (AD 164–169)
Found in Westbury-sub-Mendip in 2016. Length 522 mm.

The lead and silver mines on the Mendips were important enough to the Romans that they were under imperial control, with troops sometimes guarding the area. Access to mineral wealth in the South West, including lead, may have even encouraged the Roman invasion. This long ingot is inscribed 'IMP DVOR AVG ANTONINI / ET VERI ARMENIACORVM' ('property of the two Augustii Antoninus and Verus, conquerors of Armenia'). This names the emperors Marcus Aurelius (who had been adopted by Antoninus Pius so also used his surname) and Lucius Verus, dating it to their joint reign.

Lead was used extensively in the plumbing of the famous Roman baths (the very word plumbing comes from *plumbarium*, 'lead' in Latin) and also in pewter vessels, spindle whorls, weights and even statues and decorative items.

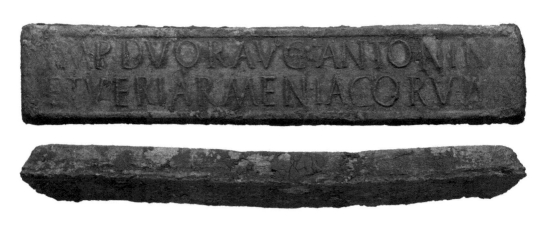

A very large lead circular tank was found cut into pieces and folded up in pit in Trudoxhill in 2018. It is highly decorated, with raised bands and small face masks. The finder and landowner kindly donated it to the Museum of Somerset so it is hoped it can be conserved and displayed in future (SOM-D21663). 🏛

This mount probably depicts the goddess Diana with her hair held by a diademed cap. Diana was goddess of hunting but also, appropriately for Somerset, the countryside and domestic animals, as well as the moon and childbirth. On the back is a square projection and remains of an iron rivet. Mounts of this type are found in Britain representing a range of deities and may have been used on ritual tripods. Roman gods were depicted on domestic wall paintings, mosaics and furniture as well in religious contexts. Roman mythology was full of gods doing very human actions – feasting, fighting and falling in love; while powerful they were not unknowable or set apart by holiness.

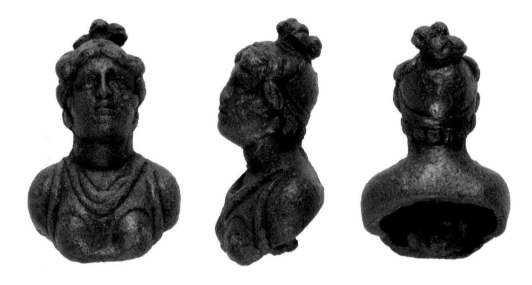

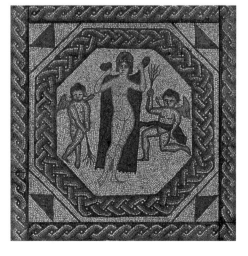

Venus from the centre part of the mosaic from Low Ham, on display in the Museum of Somerset. (Image courtesy of the South West Heritage Trust)

19. Ceramic Samian-ware bowl sherds (SOM-20F51D)
Roman (AD 120–230)
Found in Carhampton in 2017. Each sherd 76 mm in height.

Samian is one of the most recognisable types of ancient pottery in Britain. It is bright orange-red with a glossy, semi-vitrified surface. It was mass-produced, first in Southern Gaul then production moved to Central and Eastern Gaul, and Germany, and some rare types were even made in England.

This bowl would have been thrown on a potter's wheel into a mould which had been created with a series of stamps and decorated rouletting wheels. This technology made it very quick to produce large quantities of similar, highly decorative, thin pottery. Samian was an imported luxury but a relatively affordable one, found even on quite small farmsteads. It was obviously treasured; examples are known deposited in graves after being kept as an heirloom for over 100 years, and many pieces have been repaired after breaking.

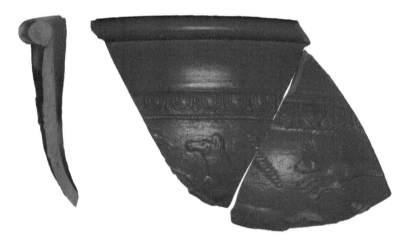

These two Samian sherds show a hunt scene under a band of ovolo moulding.

This worn, 54-mm-long piece was found in the 1970s by a schoolboy in Priddy and only recorded in 2018. Even old discoveries like this, where the findspot is still known, can be really important in understanding local industry and ways of life. It may not look impressive but is incredibly rare, one of only a few known sherds of a local imitation Samian, probably made in Wiltshire. It shows either potters had moved to exploit the new market or local potters had learnt or developed the new skills and technology.

In the second century plate brooches in a huge range of shapes became fashionable, gradually replacing the arched bow brooches. They would have held less fabric behind them so might have been worn on lighter clothing or been more decorative, rather than an integral part of how the clothing was held together.

This brooch is in the shape of a two-headed sea monster. It has punched and enamelled decoration and the green copper alloy would originally have looked more silver (if high tin) or gold (if brass). Brooches of similar style are found across north-west Europe but this is probably the best preserved example known.

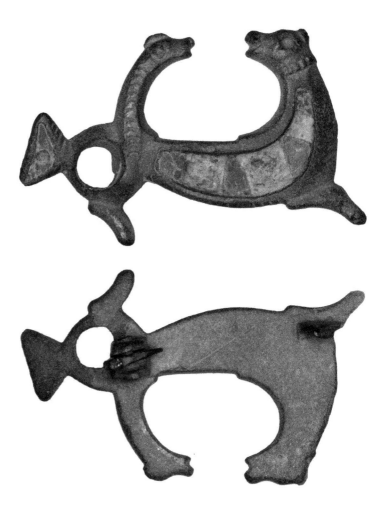

Brooch with fin on its looped tail, which ends in a second, smaller head.

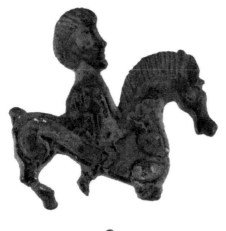

Horse and rider shaped brooch found in Orchard Portman in 2020, 31 mm across, donated to the Museum of Somerset (SOM-DCBB1B). 🏛

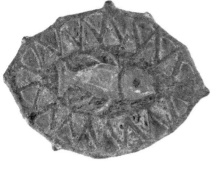

Fish on a dish brooch found in Middlezoy in 2018, 38 mm across (SOM-EE987D).

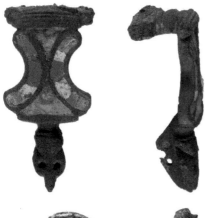

Late second- to early fourth-century brooch with bird head at base. Found in Wanstrow in 2020, 40 mm long (SOM-E074EE).

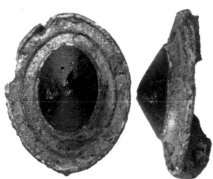

A later third- or fourth-century brooch with black glass centre found in 2016 in Saltford, donated to Saltford History Centre, 30 mm long (GLO-D087E2). 🏛

21. Copper-alloy key handle (SOM-BoC429)
Roman (AD 100–410)
Found in Ashcott in 2019. Length 51 mm.

Roman zoomorphic (animal-shaped) key handles were often in the shape of lions and wolves. This example is a fairly realistic bear with rounded ears and ruffs on the side of the squared off snout. The iron shaft and bit of the key have mostly rusted away. Details around the mouth, nostrils, and eyes are further emphasised through engraved lines and overlapping semicircular lines cover the sides of the face, suggesting fur. Such large keys would have been for buildings or secure rooms. Needing a key was a sign of status in its own right, suggesting you had things worth stealing. They were not just everyday items.

Right: Smaller keys are also found for chests and cupboards, like this wearable finger ring key found in Misterton in 2013, 20 mm in diameter (SOM-8F3994).

22. Gold finger-ring (SOM-98F54A)
Roman (AD 200–400).
Found near Ilminster in 2018. 33 mm across.

This beautiful, large ring is all about display. The elaborate openwork on the shoulders and back flanks a panel with black niello, the contrast highlighting the brightness of the gold. The very large and well-made intaglio (engraved stone) on the front shows a winged figure of Victory brandishing a whip over the two horses who pull her racing chariot (biga). The banded stone (nicolo) has a pale blue top layer, which is carefully cut through so the design shows as the dark brown of the lower layer. This area of South Somerset has many villas and was very wealthy, possibly from selling corn, in the later Roman period.

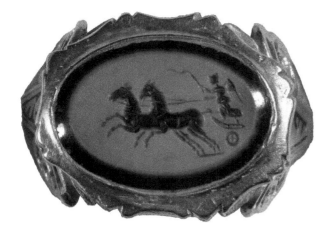

Left: View of the top.

Below left: View of the 'keeled' shape of the ring.

Below right: View of the side.

23. Copper-alloy coin (SOM-71D4C7)
Roman (AD 320)
Found in Martock in 2016. 21 mm in diameter.

This is a *nummus* (small value coin) of Constantine I (the Great), who is shown on the obverse. The reverse (tails side) carries the legend 'ROMAE AETERNAE'; the personification of eternal Rome is seated, holding a shield inscribed 'X/V'. Minted in the fourteenth year of Constantine's reign, the numerals were probably intended to celebrate his impending fifteenth anniversary.

Coins of this type are rare finds in Britain. The mint mark, at the bottom of the reverse, is particularly unusual. It has the letters R – CT flanking the word AMOR ('love' in Latin), written in Greek lettering. The letter R signifies the mint of Rome, CT indicates the officina, or workshop. The word AMOR is a palindrome of ROMA. By this time the personification of Rome was associated with Venus, goddess of love and mythical ancestor of the Roman people. The double temple of Venus and Rome was one of the largest in the city. The combination of palindrome and imagery references both goddesses and paints Constantine as the legitimate heir of Rome's supposed founders.

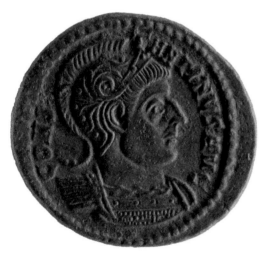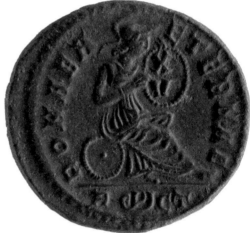

24. Copper-alloy Jupiter figurine (SOM-B5638E) 🏛
Roman (43–410)
Found in Brompton Regis in 2018. 93 mm tall.

We can recognise this statue as Jupiter due to his mature, bearded look, draped stole and most importantly the oval thunderbolt (*fulmen*) he holds in his hand. The missing hand probably held a long sceptre or was held out in blessing. This small statue is only partly finished, with rough seams left from the mould. This suggests it was made locally or crudely made just to be deposited.

Such statuettes were used in temples but also in personal shrines. Jupiter figurines are not common in Britain and are mostly found on military sites, and this example may relate to the nearby Roman fort at Rainsbury. Over the last twenty years the extensive Late Iron Age and Early Roman ironworking on Exmoor has been discovered, leading to a complete re-evaluation of the area's economic importance. Evidence for adoption of the Roman way of life or religion, *Romanitas*, is rarer. This piece is therefore of particular significance as it suggests the possible local production and use of figurines representing a specifically Roman god.

Figurine of Jupiter, donated to the Museum of Somerset by the finder and landowner.

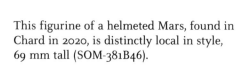

This figurine of a helmeted Mars, found in Chard in 2020, is distinctly local in style, 69 mm tall (SOM-381B46).

25. Copper-alloy buckle (SOM-D07208)
Roman (AD 350–450)
Found in Donyatt in 2008. Length 62 mm.

Towards the end of the Roman period in Britain there seems to be a range of social and cultural changes. Christianity was becoming established, towns were probably less important as a focus of political and elite life and clothing fashions also changed. This change continued after the end of official Roman rule, with towns such as Bath and Ilchester gradually declining and large gathering halls providing new, alternative venues for power and display, often on villa sites.

Buckles like this are examples of the continuation of culture across this period. They became fashionable at the end of the fourth century and continue after the end of official Roman rule, into the fifth century. The plate is not as elaborate as usual for this type of frame and may be a later addition or repair.

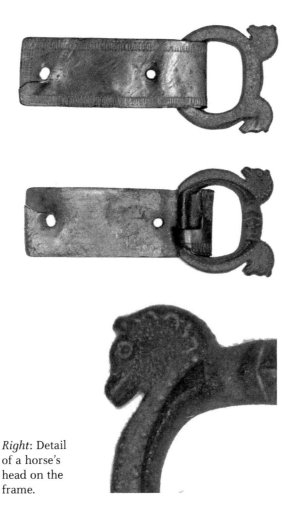

Right: Detail of a horse's head on the frame.

51

Early Medieval (AD 410–1066)

After the unified political system of the Roman period, the early medieval period is one of fragmentation and then regathering. It is likely that life continued very similarly at first for many people, but with a breakdown in wider connections. This is seen particularly in the end of mass pottery production. This lack of well-made pottery tells us something about the lack of stable, long-distance, everyday trade but also made it difficult for archaeologists to date sites before the refining of absolute dating methods such as radiocarbon dating. It is only in the last twenty-five years, with such dating techniques becoming cheaper and working successfully on smaller pieces, that we are starting to prove the continued use of many 'Roman' sites into the fifth and even sixth centuries.

More Celtic or Iron Age styles became common on metalwork again, continuing a tradition that had always existed further west, and there were strong cultural connections to Ireland, Wales and across the Channel. Christian traditions of simple burials without elaborate grave goods mean we unfortunately know less about people of this area's goods than more famous sites and kingdoms in the South East, such as at Sutton Hoo (Suffolk).

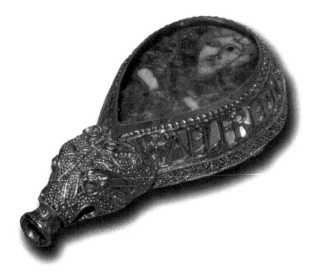

Perhaps the most famous find from Somerset is the ninth-century Alfred Jewel found in 1693, in North Newton, and now in the Ashmolean Museum, Oxford. (Photo of a replica in the Museum of Somerset courtesy of the South West Heritage Trust) 🏛

As the eastern kingdoms, some founded by various Germanic groups, consolidated and became more powerful they gradually conquered and absorbed this area during the second half of the seventh century. In the ninth century Somerset became important as a last area holding out against Scandinavian Viking invaders under the English King Alfred. Alfred hid out in the marshy levels at Athelney before launching a counter offensive in 878, culminating in the Treaty of Wedmore.

The later early medieval period saw the founding of burhs, the restarting of towns as important political and economic centres, the increasing development of powerful monasteries such as Glastonbury and the division of land into estates under the control of a legally separate elite. Money was reintroduced and at the end of the period Scandinavian influenced items became popular, even in Somerset, which was outside the Danelaw, in part due to the conquest of all of England by the Danish king Cnut in AD 1016.

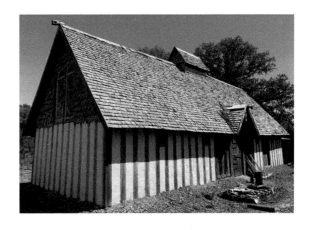

Reconstructed Saxon hall at the Avalon Archaeology Park (Avalon Marshes Centre). It was based on a grand hall excavated at Cheddar, the site of the Witenagemot gathering of the king and his nobles three times in the tenth century. (Photo by Bob Croft)

Tenth-century sculpture of St Peter, which was identified in 2004, after being used as a cat's gravemarker in Dowlish Wake, now in the Museum of Somerset. (Image courtesy of the South West Heritage Trust) 🏛

26. Gold *semissis* (coin) (GLO-A8A3F5)
Early medieval (AD 565–78)
Found in Kelston in 2010. 18 mm in diameter.

With the decline in towns, and regular trade between distant communities, coinage became less useful. Without the backing of a strong state the copper-alloy coinage, like Find 23, stopped being used. As there were no new coins coming in as pay, Roman silver coins became worn and clipped and also fell out of use through the fifth century. In Somerset it was not until around AD 700 that coins came back into common use.

In the gap between regular use of coinage there are a few imports of Continental gold coins. They may have come into Britain through trade or through other payments and gifts. Their rarity demonstrates the very sparse nature of such contacts in this period. This gold *semissis* of Justin II, Emperor of Byzantium (AD 565–78), was minted in Sicily and is the only one of the type to be found in Britain, although copper-alloy coins of the same ruler are known.

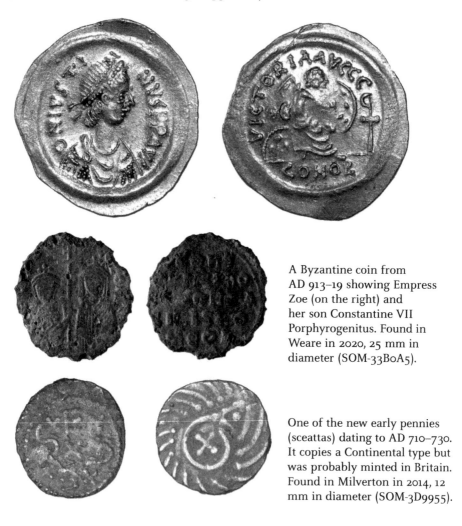

A Byzantine coin from AD 913–19 showing Empress Zoe (on the right) and her son Constantine VII Porphyrogenitus. Found in Weare in 2020, 25 mm in diameter (SOM-33B0A5).

One of the new early pennies (sceattas) dating to AD 710–730. It copies a Continental type but was probably minted in Britain. Found in Milverton in 2014, 12 mm in diameter (SOM-3D9955).

27. Copper-alloy gilded pendant (SOM-977DoB)
Early medieval (AD 530–600)
Found in Cannington in 2014. Length 33 mm.

This pendant, probably used on horse harness, employs Anglo-Saxon art styles in a sophisticated but unusual way, perhaps reflecting the taste of the owner. It dates to a period when this area, west of the River Parrett, was outside Anglo-Saxon political control and material utilising such art styles is very rare locally. The pendant has a design of two large beasts whose bodies form the curved top of the pendant and whose confronting heads, with gaping jaws, form the lower part. Within their bodies are smaller interlaced beasts. The curved bodies and jaws of the larger beasts give a similar arrangement to designs of helmeted and moustachioed faces typical on button brooches of the period. The large beasts are clearer with the loop at the bottom (the wearer's perspective), while the smaller beasts and face are clearer with the loop at the top (the viewer's perspective). Such multi-layered and ambiguous designs are typical of this period.

Below left: Coloured sketch showing the main features (shown upside down).

Below right: This pendant also uses Anglo-Saxon art styles inspired by keystone ('Kentish') brooches dating to around AD 530–560. In Somerset the style is used in a new way and on a different object: it is slightly larger, simpler, and with enamel replacing garnet or red glass. Found in Kilve in 2014, 28 mm long (SOM-07C798).

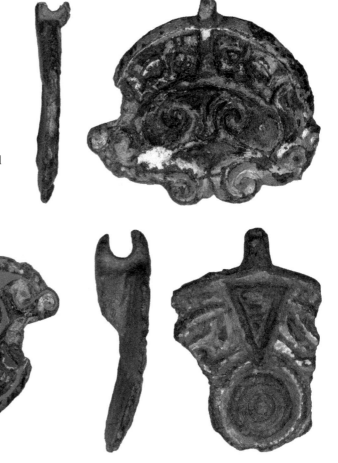

28. Copper-alloy enamelled mount (SOM-612E06)
Early medieval (AD 750–900)
Found in Easton-in-Gordano in 2015. Length 40 mm.

This piece is Irish, probably from a religious item. It was found near a good, natural, harbour on the River Avon and is almost certainly part of the spoils from a Viking raid in Ireland, sold or lost by raiders. It is not clear if the break was at the bottom, with a second rivet, as shown, or if the piece was attached the other way up with a suspension loop at the broken part.

The mount shows a human head with prominent ears between profile animals with open jaws; an image that is paralleled on other eighth-century Irish metalwork. The design of two rearing animals flanking a human is an ancient tradition in Near Eastern art, sometimes called the 'Master of the Beasts' image. On early Christian items they may represent Christ appearing between two beasts as in the prophecy of Habakkuk, or perhaps Daniel in the lion's den. The larger recessed areas held yellow enamel, surrounded by narrow channels holding red enamel, a style and colour combination popular on Irish metalwork of the period.

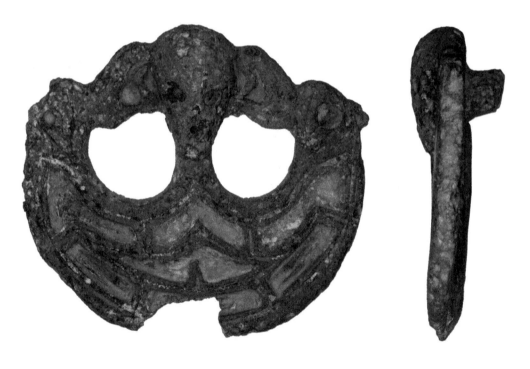

29. Silver and copper-alloy brooch (DEV-1A7D5C) 🏛
Early medieval (AD 800–900)
Found in Cheddar in 2020. 91 mm in diameter.

This large, beautiful brooch has a silver front and a solid copper-alloy backplate, and areas were originally gilded. The use of the two metals would have provided a lovely contrast, with the back highlighting the detailed openwork on the silver front. The front is decorated in the 'Trewhiddle' style, where the surface is broken up by borders into separate cells and panels, which each contains an interlaced animal or plant. Some cells are open, others solid. The pattern of cells and raised bosses on the brooch is rigidly symmetrical while the curving creatures and plants give it fluidity and movement.

As this find is so recent it is still being cleaned and conserved and the complex design interpreted. The brooch is incredibly detailed and it is important to think about who in the past would have been the audience for this detail, without the zoomable photos of today. With such a big brooch it would be visible even to people at a distance or across a large hall that you were wearing a large, impressively decorated piece. A lot of the detail, however, would only be visible to those allowed close to, or spending time with the wearer, and some might only really be appreciated by the wearer themselves.

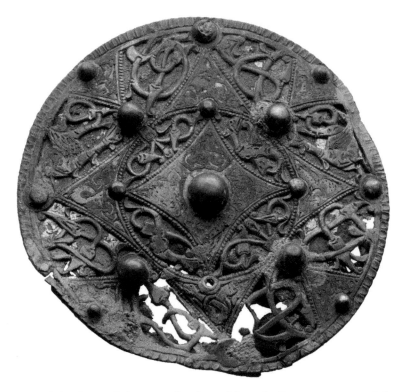

View of the front of the partially cleaned brooch. (Image courtesy of the South West Heritage Trust)

30. Copper-alloy strap-end (SOM-9ABAE0) 🏛
Early medieval (AD 875–950)
Found in Mudford in 2012. Length 41 mm.

From around AD 750 decorative metal strap-ends became very popular. Found in affordable copper alloy as well as silver they may have been worn on straps on a variety of items and parts of clothing, as well as belts. There is a large range of styles and types and some showcase new art styles.

This example is in the Borre style and probably copies examples that show an animal with central rectangular body and interlaced limbs making a complicated knot pattern. Borre-style art originated in Scandinavia and Borre influenced objects are much more common in the Danelaw areas of northern and eastern England where this item was probably made. It was donated to the Museum of Somerset by the finder.

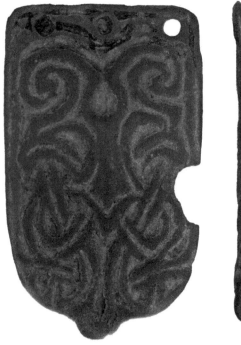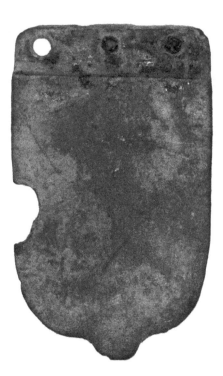

Strap-end from Mudford.

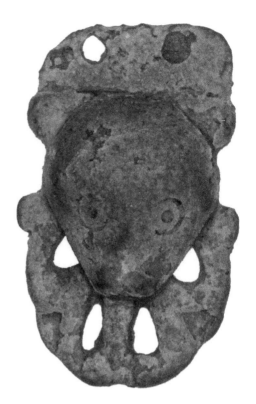

This example of similar date has a more realistic animal head with nielloed ring-and-dot eyes and tendrils branching from the mouth in the Winchester style. Found in Cossington in 2011, 32 mm long (SOM-45C877).

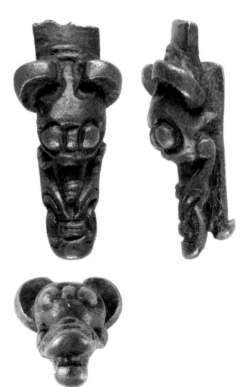

This silver terminal is also probably from a strap-end and shows Anglo-Scandinavian influence, with the tendrils coming back from the animal's mouth. Found in Staple Fitzpaine in 2017, 23 mm long (DEV-60981B). 🏛

31. Copper-alloy stirrup-strap mount (PUBLIC-9AC705)
Early medieval to medieval (AD 1000–1100)
Found in Cossington in 2011. Length 38 mm.

Horses were important for travel and war in this period but were expensive to own. Already the mounted warrior was an important role, which developed into the defined social group of *chevaliers* or knights. As owning a horse was a sign of wealth, horse gear was an important area for display; items on the harness and stirrups would be visible to a wide range of people as the owner travelled, hunted and fought. In the eleventh century sets of decorative material including copper-alloy harness fittings, cheekpieces and stirrup decorations came into use. The styles are found in England and Scandinavia, as the Danish kings Cnut and his sons ruled both areas between 1016 and 1042. They continued to be fashionable for around fifty years after the Norman Conquest.

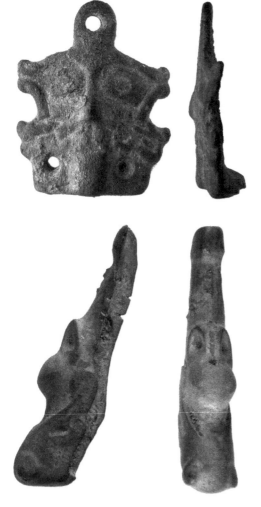

Stirrup-strap mount that went over the junction of the metal stirrup and the strap it hung from. (Image supplied by the finder)

This mount in the Anglo-Scandinavian Ringerike style would go on the corner of a stirrup. Found in Kingsbury Episcopi in 2017, 51 mm long (SOM-C2BC82).

Medieval (AD 1066–1500)

By the medieval period the landscape of Somerset would feel more familiar; most towns and villages we know today were already established with their parish churches. In other ways it was radically different. There were fewer hedges and divisions between fields and the Levels and Moors were only partly drained. Areas of the land were deliberately kept 'wild' for hunting. The population remained much lower – even the largest towns would feel small to us. Most buildings would feel small, dark and smoky, with a focus on communal and multi-use space. Usually only churches, church buildings, a few grand monasteries and castles were large and solidly built enough to survive today.

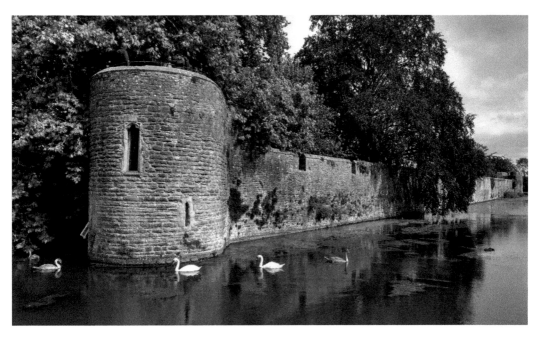

The large Bishop's Palace at Wells is surrounded by a moat, although probably more for display than defence. (Photo by Blair Webley)

Almost everyone worked in farming, growing crops for food, raising sheep for wool for fabric and managing wood and reeds. At the start of the period, they would also be semi-free, tied to give labour service to a lord and unable to move to a new place without permission. These restrictions broke down through the medieval period and many people did move at points in their life, for trade, pilgrimage and war, so they would have knowledge and contact with the wider world. Religion remained an important shaping force in people's lives, both organised religion and personal piety.

Particularly from around 1200 mass production started to re-emerge as more people could afford to buy goods for money; markets were established and trade across the country became more reliable. As well as a more connected world, artefacts also show a world that is much more joyful than the traditional picture of the peasant toiling in mud might suggest. The bright colours of wall paintings, stained glass, enamels, clothing, golden brass buckles and strap decorations, and even mass production of green glazed pottery, all illustrate a rise in personal consumption further down the social scale.

Meare Fish House was built by Glastonbury Abbey to exploit the fisheries on the Levels. (Photo by Blair Webley)

32. Silver coin hoard (GLO-D815B3) 🏛

Medieval (AD 1067–1068)
Found in the Chew Valley in 2019. Each coin is about 18 mm in diameter; total weight 3,367 g.

This hoard of 2,581 Late Saxon and Norman silver coins was buried very soon after the Conquest and contains coins of Harold II and of the new Norman king, William I (the Conqueror). In this period coin types were regularly changed. Old types had to be taken to a network of mints across the country to be re-minted, for a fee. There were eleven mints in Somerset in the tenth and eleventh centuries including Watchet, Milborne Port and Bath, although not all operated at the same time. The only denomination issued in this period was the silver penny, but these were commonly cut into halves and quarters to provide smaller values.

The hoard is worth £10, 12 shillings and 2 pence in the money of the time, enough to buy about 500 sheep, equivalent to the annual income of a medium-sized estate, or about a fifth of the annual taxes paid by the entire Chew Valley. In this period, just after the Norman Conquest, there was a lot of uncertainty, with various rebellions against William. Exeter was besieged in early 1068 and the sons of the Harold II attacked Bristol and marched through Somerset in late 1068 in an unsuccessful attempt to reconquer England. The owner may have buried the hoard as a response to such direct threats of looting or because the general disruption made it difficult to spend or transport the money safely.

Some coins are now in the British Museum and the rest in the Bath Museum.

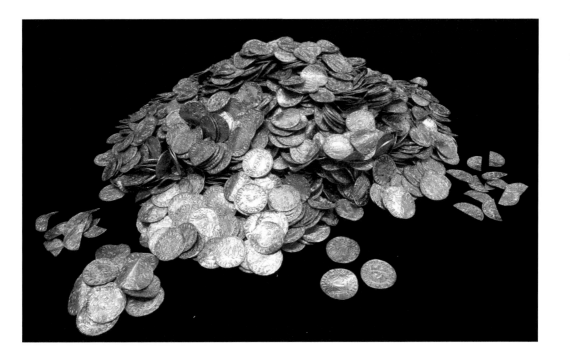

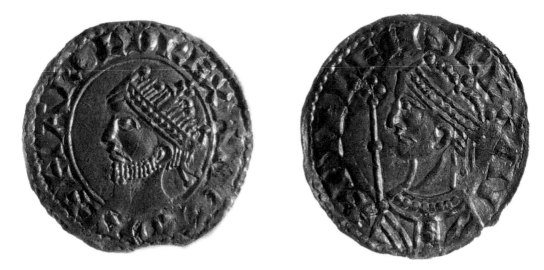

The portraits are stylised but show Harold II (on the left) as bearded and with longer hair than William (on the right).

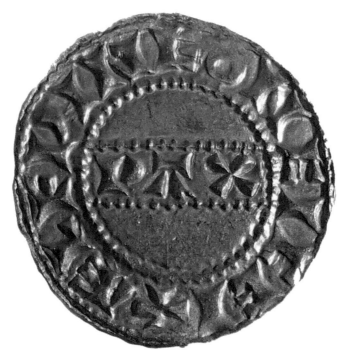

Around half the coins are PAX types of Harold II, a king whose ten-month reign saw two invasions.

33. Copper-alloy, gilded and enamelled plaque (SOM-862DDC)
Medieval (AD 1175–1225)
Found in Chiselborough in 2019. Length 53 mm.

This beautiful plaque may have decorated a small chest, shrine or book. It was probably made in Limoges in France, where a huge industry created religious, and some secular, enamelled objects which were popular across Europe. The inscription reads: 'IhS / NAZA/RENV/S : REX / IVDE/ORVM' ('Jesus of Nazareth, King of the Jews'). The bright but opaque enamel echoes dark blue lapis lazuli and light turquoise stones.

Mounts from Limoges were widely used on crucifixes, including this example found near Barlynch Priory on Exmoor. The mounts came in a set of four representing the four gospel writers, one at each end of a crucifix arm, with Christ in the centre.

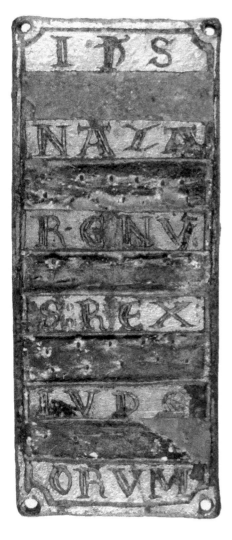

Detail showing the dark blue enamel in the letters and border and keying for the missing turquoise enamel.

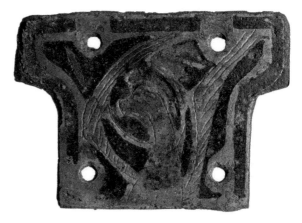

Mount with the Eagle of St John found in Brompton Regis in 2017, 40 mm high (SOM-D7A414).

Ampullae are small containers for holy relic water. Bought by pilgrims at shrines, the water was considered specially blessed by association with the saints venerated there. In Britain they are usually made in lead. Often the designs are simple, with the oval body decorated with raised lines echoing a scallop or cockle shell. The scallop was the symbol of pilgrimage due to its association with St James (the Great) of Compostela, the most important pilgrimage site in Western Europe after Rome.

This ampulla is much more decorative and very unusual. On one side is St James the Great with the attributes of a pilgrim – his bag (or scrip) and staff from which is hung a scallop shell. To the left is a large hand, referring to the holy relic of the hand of St James given to Reading Abbey by the Empress Matilda in 1133. The inscription on the external band reads: '+ IMAGO . SCI . IACOBI . APLI . DE . RADINGIIS +' ('Image of St James the Apostle of Reading'). At the Dissolution of the Monasteries in 1539 the monks hid the hand, their most important relic, in an iron chest in the walls of Reading Abbey. It was found 250 years later and can now be seen in St Peter's Church, Marlow.

The opposite side depicts St Philip, who holds a staff and scroll. To the saint's right are a head and shoulders in profile, which alludes to the holy relic of the skull of St Philip, also held at Reading Abbey. On this side the inscription reads '+ IMAGO . SCI . PHILIPPI . APLI . DE . RADINGIIS +' ('Image of St Philip the Apostle of Reading'). Image supplied by the finder.

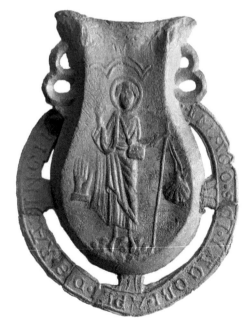

Side showing St James.

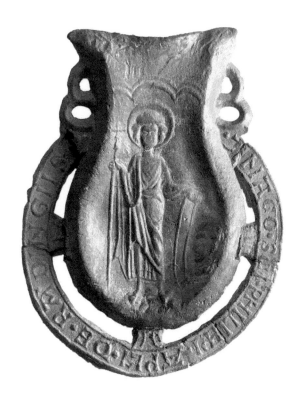

Side showing St Philip.

Ampullae are often found torn open after the water inside has been used, probably in a church ceremony, to bless the fields, or as a cure. This shell-shaped one was found in Combe St Nicholas in 2018 and is 47 mm tall (SOM-117896).

35. Copper-alloy buckle (SOM-0D42E7)
Medieval (AD 1200–1300)
Found in Cheddar in 2020. Length 44 mm.

After coins, buckles are the most common items reported to the PAS. Without zips or Velcro they were used to fasten everything from your shoes to your bag. Buttons didn't become popular until the closer fitting fashions of the fourteenth century and, even then, buckles remained in use on many parts of clothing, harness and other objects. By around 1200 buckles were mass produced, with similar types being found all over the country and moulds for casting dozens at once found in several English cities.

This highly decorative but tiny buckle is of a form popular in the thirteenth century. The same shape is found on examples many times bigger, which were probably used on sword belts. This diminutive example may have been used as a matching set elsewhere on a sword harness or another object.

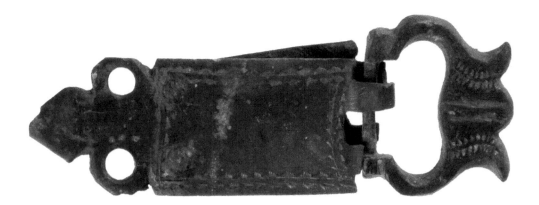

36. Lead-alloy seal matrix (SOM-721AF8)
Medieval (AD 1225–1325)
Found in Langford Budville in 2016. Length 49 mm.

Seal matrices were used to finalise legal documents instead of a signature. From the thirteenth century they were increasingly used by everyone who owned land or had a business as sealed documents supplemented verbal promises in transactions. This example is a fairly simple, cheap seal but it was inscribed specifically for the owner with her name. It reads: 'SIGILL . GVNIL RELICTE . T . d'PIL', which translates as 'Seal of Gunhilda widow of T[...] of Pil'. The matrix is fragile and cracked and has lost the top corner, which may have included a projection on the back for a handle.

The size and simple style of the matrix might suggest a thirteenth-century date. Intriguingly, one or two Gunhilds are known at nearby Cothay in the early fourteenth century. Two preserved documents show Gunhild, sister of William of Cothay and wife of Thomas, owned land locally in 1309, as did John de Wyslaurgh and his wife Gunhild in 1324. This second Gunhild may be the daughter of the first, or the same person who has remarried. The seals attached to these documents are unfortunately not ones from this matrix.

While later than the style of matrix might suggest, the Gunhild mentioned in the first document is a strong candidate for the owner of this seal as she had a relatively unusual name, was married to a Thomas and owned land locally and therefore would have need of a seal matrix. Piley Lane runs south-east out of Cothay to a Piley Copse to the east, a possibility for the place name mentioned on the matrix. It is rare we can link an object to a specific owner and we can't rule out that it belonged to someone with the same name for whom no documents happen to survive, perhaps an earlier member of the family, if it is a traditional family name.

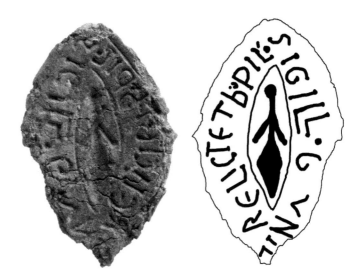

The seal (on the left), with a sketch of the inscription shown as it would appear on the seal impression.

69

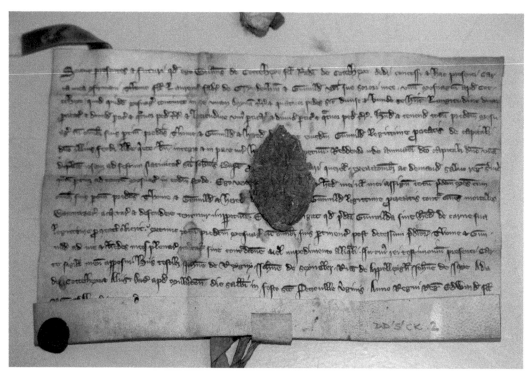

The seal matrix shown with one of the documents preserved in the Somerset Record Office.

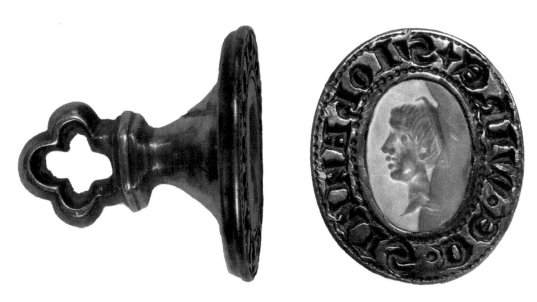

This grander silver seal matrix with reused Roman intaglio was found in Bratton Seymour in 2018 and is 22 mm high (SUR-36D8C9).

37. Billon denier (coin) (SOM-0C7D00)
Medieval (AD 1296–1324)
Found in West Bagborough in 2019. 13 mm in diameter.

A medieval denier of Henry II of the Kingdom of Cyprus (1285–1324). He was also titled King of Jerusalem, although that kingdom was entirely lost by 1302. The coin is of the 'lion' type but the mint is uncertain. It is made of silver mixed with copper (billon). The name denier comes from the Roman *denarius* and it was a coin equivalent to the penny.

English medieval kings were very successful in maintaining coinage at the high sterling silver standard. Some foreign silver coins did circulate, unofficially in the case of sterling imitations, or officially like the Burgundian patards, but most people would not accept a debased silver coin like this as payment. It may have been brought back by a pilgrim or merchant travelling to the Mediterranean. In the later medieval period, shortages of small change led to large numbers of Venetian silver soldini being deliberately imported to use as unofficial halfpennies, so-called 'galyhalpens'.

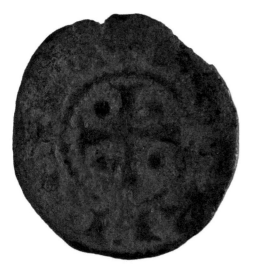 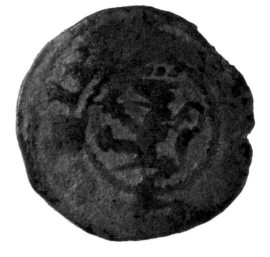

Denier of Henry II.

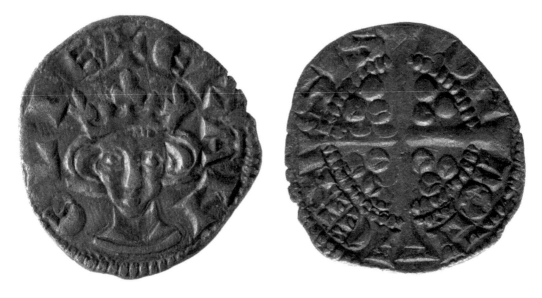

English farthing (quarter of a penny) of the same period, found in Shoscombe, 11 mm in diameter (SOM-7C24C7).

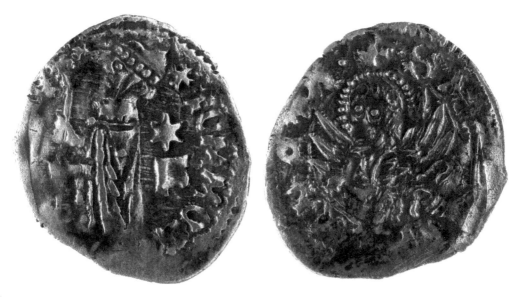

Venetian soldino of Doge Tommaso Mocenigo dating to 1413–1423. Found in Barrington in 2018 and 15 mm in diameter (SOM-05212E).

Find 38. Iron and wood dagger (GLO-D8BD87) 🏛
Medieval (AD 1400–1500)
Found in Stanton Drew in 2008. Length 493 mm.

Iron and wood are both quickly broken down in the soil, by rust or microbes. This dagger only survived because it was lost or buried in the silt on the side of the river. This sealed it from oxygen, which is needed for rust to occur, or for the fungi that cause decay to live.

It is a rondel dagger, so called because of the large round plate at the end of the hilt. They often have a large circular hand guard as well. This is a weapon that would be used as a side arm by knights or men at arms. Similar daggers were also worn by non-military people, such as merchants, for defence. Wearing a long dagger or light sword, as well as a knife for eating and utility, seems to become more common amongst many classes in the fifteenth or sixteenth century but it is not clear if this is due to a more violent society, fashion, or because more people could afford such items. Donated to Bath Museum by the finder.

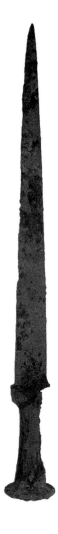

Find 39. Gilded copper-alloy pilgrim badge (SOM-315A8C)
Medieval (AD 1475–1500)
Found in Othery in 2017. 45 mm in height.

In the late medieval period there seems to be a shift to greater personal devotion to particular saints and to individual, private religious worship. Badges like these may have been purchased locally as well as on pilgrimage. The badge would have been attached by sewing or pinning through the loop on the back.

St George, a third- or fourth-century soldier born in modern-day Turkey, became an increasingly popular saint in England from the fourteenth century onwards, when he started to be associated with military prowess and nationalism. This very naturalistic, active, violent, portrayal of St George in the act of killing the dragon is typical of the new art of the Renaissance. The detail on the armour and shield allows us to attribute a very precise date to the piece. Only the tip of the sword is missing.

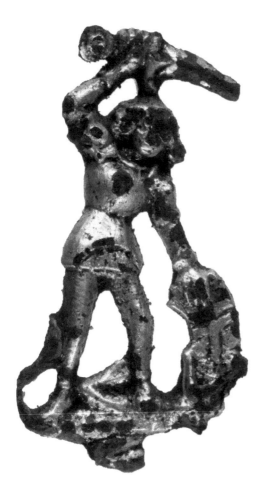
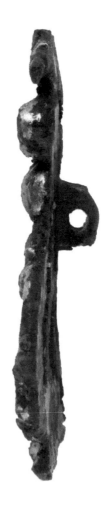

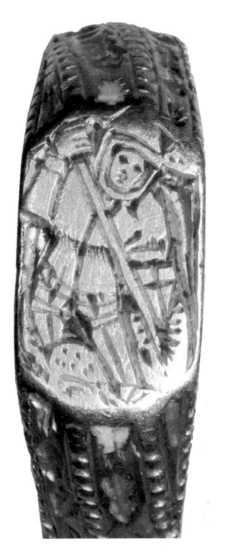

Iconographic finger rings depicting various saints were fashionable items of personal devotion and display in the fourteenth and fifteenth centuries. This example also shows St George and the dragon and was found in Nynehead in 2014 and is 22 mm wide (SOM-21BA62).

This broken pilgrim badge shows St Hubert and his vision of a cross between a stag's antlers. It is of a type made in northern France and was found in West Bagborough in 2018. It is 24 mm in length (SOM-DB8BAE).

40. Antler hornpipe (SOM-17C1D5)
Medieval or post-medieval (AD 1250–1800)
Found in North Cadbury in 2012. Length 148 mm.

This end-blown hornpipe has a rough surface from the worn antler and seven finger holes down the front. It would have had a separate mouthpiece at the narrow end, which probably held a reed. A thumb rest on the back made it easier to hold and play one handed.

Such fragile pieces in organic material do not survive often and the use of antler is unusual as most pipes are in horn or wood. Three-hole examples are known by the eleventh century in London, and by the thirteenth century there are examples in Poland that look similar to this one. Once developed, the style did not change much for centuries. The pipe was found in a back garden behind an old inn with medieval pottery and some seventeenth- and eighteenth-century pottery so could be of either date.

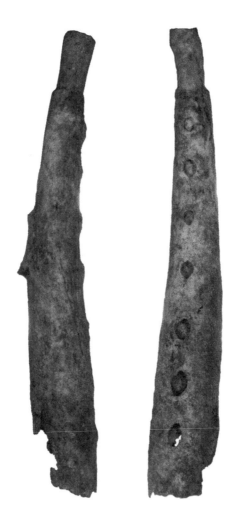

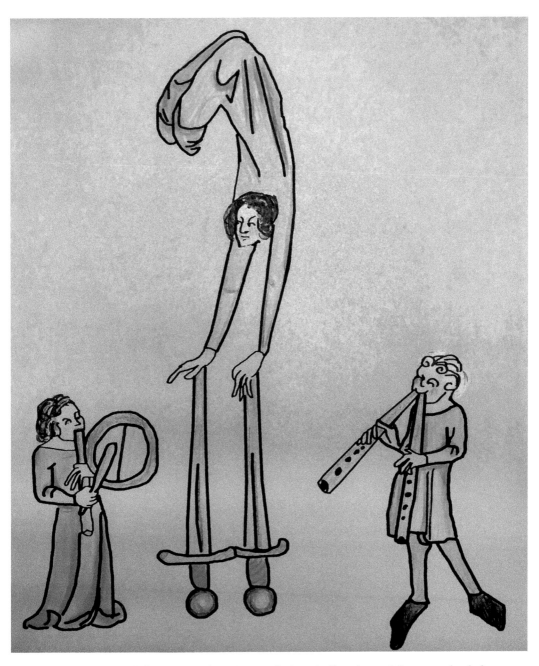

Redrawn medieval illustration of musicians playing similar pipes while an acrobat balances on swords. Original made around 1340, probably in France, now in the British Library.

Post-medieval and Modern (AD 1500 to now)

This period, more than any other, has shaped and created the world we live in today. The higher population, rise of urban society, industrialisation and increased pace of movement and technological change all helped radically reshape the way we live. With the arrival of printing and paper in the West from China, it is also the period from which we have most written records, pictures, maps and later photos and videos. In this mass of historical information, the contribution of archaeology to understanding our past can be less obvious than in early periods.

Archaeology, however, still provides an important insight, particularly into the lives of those less likely to appear in historical record, such as the poor and children, who after all were the majority of the population. Artefacts provide important evidence of subjects where records may have been ephemeral or not collected at all, such as economics and business, private beliefs and informal dress. Objects can also provide a physical, tangible link to events. In doing so they confront us with their reality and the experience of the individual humans involved in the events of the twentieth and twenty-first century, just as much as a Palaeolithic handaxe does for an earlier period.

Somerset as a county has borne witness to many of the changes of this period and many sites can be visited today. The North Somerset coalfields and cloth mills of central Somerset tell a traditional story of industrialisation, but also of early de-industrialisation. Other industries such as stone mining, agriculture and shipping, now out of Avonmouth, remain important today. The reshaping of the countryside through enclosure and draining of the Levels and Moors has had a major impact on our physical environment. Wars have also left their mark, from the last acts of the Wars of the Roses played out with the trial of Perkin Warbeck at Taunton Castle in 1497, to Somerset's central role in the English Civil Wars, including the Battle of Langport in 1645, through the Monmouth Rebellion and Battle of Sedgemoor in 1685 to the First and Second World Wars and the importance of Yeovil and Weston-super-Mare for aircraft and helicopter manufacture. The rise of easier travel and leisure made major impacts, first on Bath in the late eighteenth century and then on the Somerset coast as resorts such as Minehead, Weston-super-Mare and Burnham changed their fishing and port focus to tourism.

Right: The South Drain, which drains the southern Brue Valley near Glastonbury. Dug in 1806, it was one of the last parts of the extensive works that drained the Levels for agriculture. This area still floods most winters, but this leads to rich, early, grass growth. (Photo by Stefan Webley)

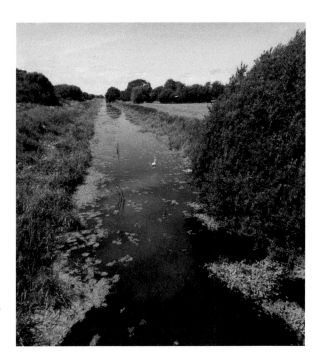

Below: The wealthy people attracted to Bath in the late eighteenth and early nineteenth century, for health and entertainment, have left a legacy of beautiful buildings. (Photo by Blair Webley)

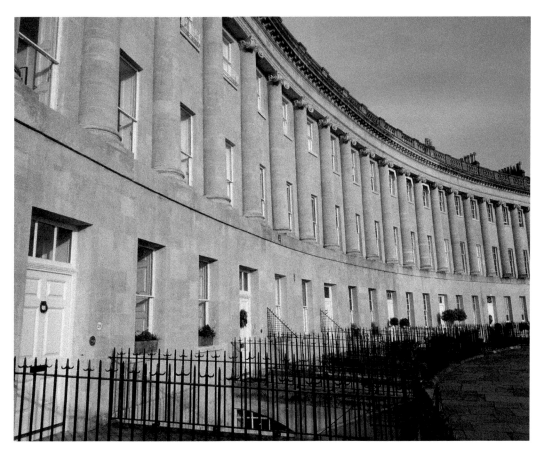

41. Copper-alloy signet ring (SOM-B5D177)
Post-medieval (1400–1600)
Found in Binegar in 2012. 27 mm across.

Unlike the medieval seal matrices like Find 36, by 1400 seals were mostly used to seal closed letters as signatures became more important on legal documents. These seals were more generic and only identified the individual to people who knew them well.

The crowned initial is a common device, which shows that the owner's first name began with G. They have paired this with a crowned pair of scissors, which is highly unusual. On tokens and shop signs scissors usually denoted a tailor, or they could be the shears of a clothier (someone involved in the cloth trade).

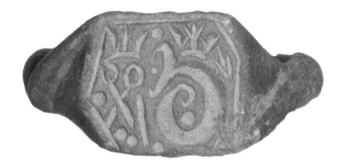

Right: This seventeenth-century ring shows Noah's Ark with prominent dove. The device seems appropriate given how often parts of Somerset are at risk from flooding. It could even commemorate the deadly 1607 floods, which killed many people and animals and destroyed houses around the Bristol Channel. Found in Carhampton in 2012 and 24 mm long (SOM-47D548).

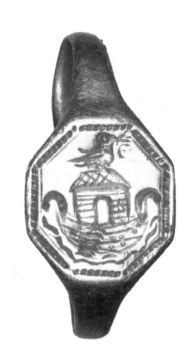

Below: While we can only speculate about the other two seal rings, this seal matrix's owner can be precisely identified. It shows the arms of Sir John Portman impaled by those of his wife, Anne Gifford. It must have been made in the thirteen months between him being made a baronet in 1611 and his death in 1612. Found in Orchard Portman in 2014 and 29 mm high (SOM-19831E). 🏛

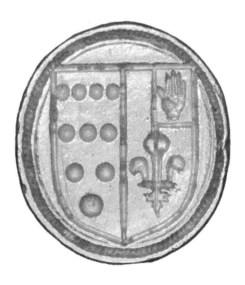

42. Silver-gilt dress-hook (SOM-o68DE2) 🏛
Post-medieval (1550–1650)
Found in Chilthorne Domer in 2019. Length 28 mm.

In the sixteenth century sharp-hooked dress hooks became an important part of dress for middling and poorer women. They seem to have been used in pairs to hitch up the ends of long voluminous skirts when working or walking in muddy areas. Because of this, although they were very popular, they are not shown in posed portraits and paintings.

This beautiful dress hook, in the shape of an elaborate flower, would originally have had a loop at the top, probably for attachment to a tape that hung down from the waist, while the sharp hook went through the loosely woven outer skirts. Dress hooks are found in silver, sometimes with gilding, but also in copper alloy and even lead-tin, which would mean even very poor women could afford them.

43. Gold finger ring (GLO-864248) 🏛
Post-medieval (1550–1650)
Found in Backwell in 2011. 21 mm in diameter.

This romantic gimmel ring is made from two interlocking bands. On the inside edge of each band is an inscription which reads: '* WITH . HART . AND . HAND / I . MADE . THIS . BAND *'. This romantic inscription is figurative but also literally describes the ring, which had a hand with decorative cuff on each band, one of which is lost, and a small, incised heart in the centre of the remaining hand. This heart, and the inscription, would have been hidden when the bands were fitted together into a single ring with the hands clasped.

Puzzle or gimmel rings, with multiple bands that fitted together, were popular in the late sixteenth and early seventeenth centuries. It may have been given as a promise (engagement) ring. We often think of marriage as a very formalised and often religious ceremony but in the medieval and early modern periods it was the clear statement by people that they wanted to be married, made in front of witnesses, without coercion, that was legally binding. The giving, and acceptance, of tokens like rings was important in making this intention clear. Now in North Somerset Museum.

Right: The ring opened up to show the inscription.

Below: The front of the ring, shown with the two parts fitted together. The engraved heart is visible in the centre as the second hand, which once covered the heart when the ring was 'closed', is missing.

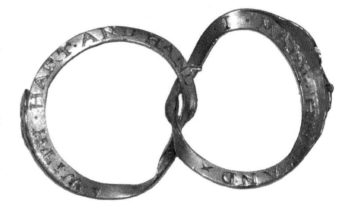

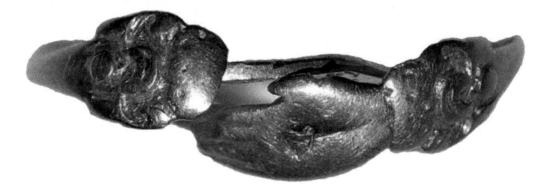

44. Lead toy soldier (SOM-CA72E2)
Post-medieval (1600–1650)
Found in Cheddon Fitzpaine in 2019. 49 mm high.

The toy soldier is in early seventeenth-century military dress, of a style popular in the Netherlands and brought back into England by people who travelled to fight in the Dutch wars. He wears baggy breeches and a fitted, sleeveless jerkin over a jacket or shirt with baggier sleeves. The jerkin has buttons with braid frogging. The trousers and sleeves are depicted with criss-cross decoration, probably a woven patten like tartan. He holds a short baton and the base of a larger weapon, perhaps a long musket or pike. A belt has a rounded bag at the side, possibly for musket balls.

The dress on this example is earlier than other 'soldier flats', which suggests this type of toy was made about fifty years before previously thought, or it was imported from the Low Counties in the earlier seventeenth century, before domestic production began.

Toy cannons were popular between the seventeenth and early nineteenth centuries. Examples found with explosion damage show the cast barrels could be used to fire actual balls. The thin metal gun carriages and wheels seldom survive. Found in Pitminster in 2010 and 78 mm in length (SOM-D20D91).

45. Gold half unite of Charles I (WILT-852CB5)
Post-medieval (1643)
Found in Priston in 2013. 28 mm in diameter.

A half unite of this period was worth 10 shillings, equivalent to 120 pence. This coin was minted during the English Civil War at Thomas Bushell's mint, Oxford. Its reverse legend combines Psalm 68:1 with a Latin translation of Charles's declaration at Wellington (Shropshire) in 1642, that he would protect 'the Protestant Religion, the Laws of England, and the Liberty of Parliament'. The coin has been bent in two places but in opposite directions giving it a Z shape in profile; it has also been pierced with a round hole.

Crooked coins bent in this way were common in the seventeenth and eighteenth centuries. Often referred to as 'love tokens', they could be given as a romantic gesture but also had a wider use as good luck charms and offerings. Piercing allowed the coin to be worn or sewn to clothing. The choice of this specific coin may suggest this was a token or charm used for its political or religious association with Charles I, who was declared a martyr by Catholics after his beheading, rather than romantically.

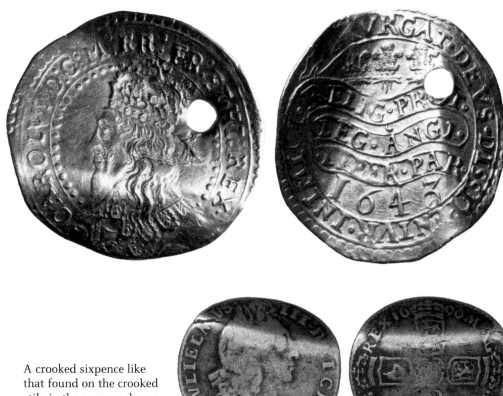

A crooked sixpence like that found on the crooked stile in the nursery rhyme. Found near Wellington in 2013 and 21 mm in diameter (SOM-5320B1).

46. Copper-alloy dog collar (SOM-DAD21E)
Post-medieval (1676–1680)
Found in Ashcott in 2016. 164 mm in diameter.

The collar is inscribed with the legend: 'Samuell Birch (shield of arms) att Shilton neare Burford in Oxfordshir[e] 1676'. Iron ring hasps would have linked the holes in one end with the vertical slots on the other and would also have attached to a swivel for the leash.

Samuel Birch (1620–1680) was a major in the Parliamentarian army where he fought under his brother Colonel John Birch. Their regiment in the New Model Army helped capture Bridgwater in July 1645, amongst other successes. After the end of the Civil Wars Samuel became a minister, but at the Restoration in 1660 he refused to follow the reinstated traditional Church of England services and teachings and was ejected from his parish. He moved to Shilton, Berkshire, in 1664 and he opened a 'conventicling' school for the sons of Dissenters, which was very popular.

The size of the collar suggests that it was worn by a large-necked hunting dog. Samuel Birch had connections across the country from his ministry, studies and teaching, and perhaps less happy ones from his military service. He was presumably visiting locally when the collar, and perhaps his dog, was lost between 1676 and his death in 1680.

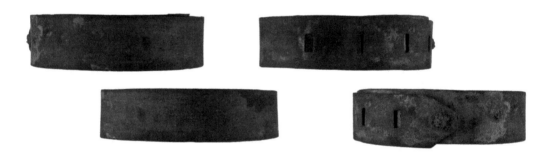

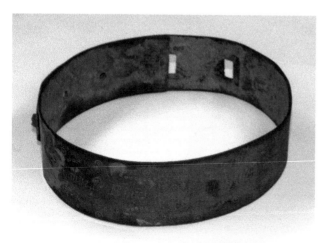

Above: The sides of the collar viewed straight on.

Left: Angled view to show the whole shape.

Detail from an Italian plate of 1610 depicting a huntsman and a dog wearing a similar collar. Now in the Musée national Adrien Dubouché, Limoges.

47. Copper-alloy trader's token farthing (WILT-BB5D16)
Post-medieval (1666)
Found in Kingsdon in 2013. 16 mm in diameter.

In the mid-seventeenth century, the government, partly due to the disruption of the Civil Wars, Commonwealth and Restoration, did not produce enough small change. There were not enough farthings, halfpennies or even pennies – the equivalent of us having nothing under a £5 note to shop with. Thousands of local merchants and town councils stepped in, issuing their own coinages. These provide a wonderful snapshot of businesses, towns and villages in the period. They are also a physical link to a specific, named, person, often telling us their business and details such as if they were married. This is rare outside objects owned and used by the elite.

Henry Mabson, hosier of Glastonbury, issued this token in 1666. A hosier made long, thick, woollen socks (called hose or stockings) worn by men and women – one is shown on the token. Usually, men wore them with loose breeches that were tied at the knee. Henry's wife's initial (M) is also given on the reverse; wives were commonly involved in the shared family business.

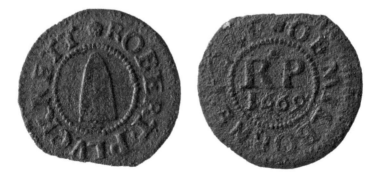

The triangular shape on this token is a cone of sugar, which would be scraped to get flakes and crystals. Sugar was sold by grocers and apothecaries (chemists) and cones used in shops could be up to a metre tall. Sugar became more popular in this period and the issuer is advertising their new product. The rise in demand for sugar and tobacco drove the horrific expansion of the slave trade. Found in Milborne Port in 2019 and 17 mm in diameter (SOM-54FE14).

48. Lead cloth seals (SOM-FBAE42, SOM-FC748C, SOM-8EA94D and SOM-BFA41A)
Post-medieval (1754–1795)
Found in Wellington in 2014 and 2015. Lengths: 23 to 30 mm.

In 2014 six lead seals were recorded from fields on the edge of Wellington. All were attached to cloth made by Were's and Co. or their successor firm, Were's, Matravers and Fox. The firm, now known as Fox Brothers & Co. Ltd, is still in business in Wellington and is one of the few local reminders of the once internationally important wool cloth trade in Somerset and Devon. Seals were attached to medieval and later cloth to show its quality, length, who made, dyed and exported it and even who inspected it and that taxes had been paid. Most such seals are found where the cloth was used, but it is possible these seals were discarded for some reason by the manufacturer.

One seal has the inscription 'SAML. BUR[RI]DGE . TIVERTON' on one side with a merchant's mark incorporating a foot. Burridge died in 1734 but his name with the Foot mark (originally that of his grandfather, Samuel Foote) continued in use to designate a particular grade of 'Taunton' serge. The quality was high in the late seventeenth century but later the name signified middling cloth of a type favoured by the Dutch. After 1754, Thomas Were & Sons of Wellington adopted these respected, established trademarks, maybe buying them from Tiverton merchants.

Four seals labelled 'WERE'S &. Co, WELLINGTON' all have numbers on the back, probably relating to length (in yards) or widths (in inches). The last seal is the latest and reads 'WERES MATRAVERS & FOX WELLINGTON' around a coat of arms. Thomas Fox and Stephen Matravers were admitted as partners to the company in 1772 and Matravers died in 1795.

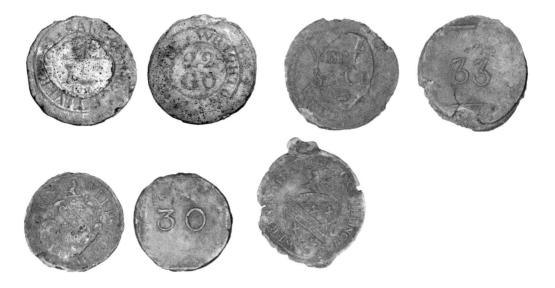

The Tonedale Mills, built in the 1750s in Wellington, employed thousands of people at their peak.

49. Copper-alloy and enamel medal and cap badge (SOM-7EDC5E)
Modern (1935–1945)
Found in Brympton in 2019. Length 39 and 35 mm.

This military cap badge and football medal were found together, the medal tucked behind the badge. The name C. Brown is inscribed on the back of the medal. Brown was almost certainly stationed in Yeovil during the Second World War. He must have won the medal in a school football league before the war and kept it with him as a good luck talisman, or happy memento, behind his badge. The find was made in a back garden on a modern housing estate now covering part of the old military camp.

The badge is that of the 6th Battalion of the Hampshire Regiment, which became known as Duke of Connaught's Own in 1883. A strip-like clip on the back of the cap badge bore the name Firmin of London, a major producer of military buttons and other goods still in existence.

50. Fused lump of mixed metal (PUBLIC-8ECB27)
Modern (2008)
Found in Weston-super-Mare in 2017. Largest piece: 120 mm in length.

In 2008 the end of Weston's Grand Pier, and its pavilion, burned to the waterline. Up to £100,000 in cash was thought to have been melted and mangled in the fire, mostly from the pier's 370 slot machines. These two melted, fused and solidified lumps of metal alloys are still in some places recognisable as coins: a mix of 50, 20, 10 and 5ps.

The pieces were found in the shingle near the new pavilion. These physical remains are modern but could provide archaeologists of the future with a snapshot of the low value coinage in use at the time. In their fused and twisted state, they provide tangible evidence of a dramatic, disastrous event in Somerset's recent history.

The rebuilt Weston Pier. (Photo by Ollie Taylor/Shutterstock.com)

Conclusion

This book has only allowed a glimpse into some of the thousands of finds recorded by the PAS from across Somerset. I hope it has also provided a small insight into how such finds can be used to learn more about the people who lived, worked, prayed and loved here in the past.

While this book focusses on individual finds we learn most by considering finds as groups and in contrast to others. Understanding how the style and use of objects vary across the country and landscape, and across time, allows us to interpret objects in new ways and gain a deeper knowledge. It is also important to understand finds in the context of the site they come from and other finds found with them. These sites and contexts are fragile and destroyed over time. It is amazing to think how much has survived to the modern day, but if sites and objects are to survive for the future they need careful preservation, by museums, farmers and everyone who digs the soil or finds an object.

There are always new finds being made and new questions we can ask of old finds, whether through technology or because what we want to learn has changed. Perhaps this book will inspire you to think of new questions you would like to ask about the area you live in or about people of the past, physically so like us and yet living in completely different cultural and social worlds.

Useful Sources

All the finds in this book are recorded on the Portable Antiquities Scheme database and you can read much more about them there: www.finds.org.uk/database. The website also provides very useful guides to all types of finds and has links where you can read annual round ups of important finds.

If you are interested in learning more about sites across Somerset the County of Somerset and BANES historic environment records are online at www.somersetheritage.org.uk. You can search by area or type of site. The North Somerset record is at www.map.n-somerset. gov.uk/HER.html and Exmoor at www.exmoorher.co.uk/.

If you want to develop a deeper understanding of objects from a particular period there are specialist finds research groups including the www.laterprehistoricfinds.com/, www. romanfindsgroup.org.uk, and www.findsresearchgroup.com (for finds from AD 700–1700).

Locally there are many active history and archaeology societies who run talks, events and even excavations. The county society is the Somerset Archaeological and Natural History Society; it publishes an annual journal which includes a PAS finds roundup and can put you in touch with local societies: https://sanhs.org/.

The Somerset Heritage Centre in Norton Fitzwarren, where the Historic Environment Record, Finds Liaison Officer, county archives, Somerset museum collections and SANHS are all based.

Information about the PAS

The PAS records archaeological finds made by members of the public through their network of Finds Liaison Officers (FLOs).

They are always keen to hear about your finds and make detailed records of as many as they can. Contact details for all the local FLOs can be found on the PAS website: www.finds.org.uk. The Somerset officer is based with the South West Heritage Trust in Taunton. The Bristol FLO covers North Somerset and BANES. Both regularly hold finds days across the area.

The scheme covers England and Wales. Scotland, Northern Ireland and the Isles have different systems and laws about finds and metal detecting. FLOs also deal with Treasure; not always as exciting as it sounds, this is legally defined material which is considered property of the Crown and must be reported to the coroner. More details of the Treasure Act, what constitutes Treasure, and how to report it can be found from FLOs or at www.finds.org.uk/treasure.

If you are planning to look for objects, by fieldwalking or metal detecting, you must have permission of the landowner. All land, even verges and beaches, has a landowner. Apart from Treasure, all finds belong to the landowner, so you must agree with them in advance what will happen to anything you find. Please do report your finds so they can continue to add to everyone's knowledge. Every small piece of pottery or worn coin is an important part of building a larger picture.

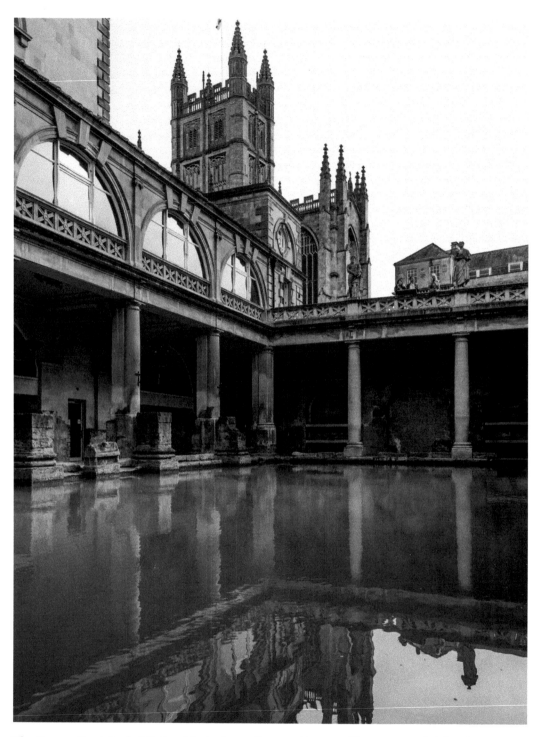

The Roman Great Pool at Bath with the base of square Roman pillars, surrounded by elegant eighteenth- and nineteenth-century rebuilt pillars and concert room with the medieval abbey church behind. (Photo by Rachel Claire from Pexels)